COUNTY DURHAM AND
NORTHUMBERLAND

THE BRITISH ACADEMY

CORPUS OF ANGLO-SAXON
STONE SCULPTURE

Volume I

COUNTY DURHAM
AND
NORTHUMBERLAND

PART TWO

BY

ROSEMARY CRAMP

PUBLISHED FOR THE BRITISH ACADEMY
BY THE OXFORD UNIVERSITY PRESS

Oxford University Press, Walton Street, Oxford OX2 6DP

OXFORD LONDON GLASGOW NEW YORK
TORONTO MELBOURNE WELLINGTON CAPE TOWN
IBADAN NAIROBI DAR ES SALAAM LUSAKA ADDIS ABABA
KUALA LUMPUR SINGAPORE JAKARTA HONG KONG TOKYO
DELHI BOMBAY CALCUTTA MADRAS KARACHI

© *The British Academy, 1984*

COUNTY DURHAM AND NORTHUMBERLAND

British Library Cataloguing in Publication Data

Corpus of Anglo-Saxon stone sculpture
Vol. 1: Durham and Northumberland
1. Sculpture, Anglo-Saxon—Catalogs
2. Stone carving—England—Catalogs
I. Cramp, Rosemary
730′.942 NB463

ISBN 0–19–726012–8

Printed in Great Britain
by The Eastern Press Ltd.
London and Reading

COUNTY DURHAM AND NORTHUMBERLAND
PART TWO

CONTENTS

ACKNOWLEDGEMENTS AND COPYRIGHT

With the exception of those listed below, the photographic illustrations for this volume are the result of the painstaking work over many years of Mr. T. Middlemass. The copyright of these is held by the University of Durham.

The following persons have kindly provided negatives and have allowed them to be reproduced here: Miss M. Firby (1229–32); Mr. S. Wilson (1425); Mr. D. Wright (904). Numbers 1088, 1426 and 1438–9 are the author's.

Many institutions have granted permission for the photographs of which they hold the copyright to be reproduced. They are: the British Museum (85–7, 437–42, 445–9, 592–5, 1421–2, 1424); Cambridge University, Museum of Archaeology and Anthropology (61–4); the National Museum, Edinburgh (483, 486, 1437); the Royal Commission on the Ancient and Historical Monuments of Scotland (1430–6); the Scottish Development Department (1427–8); the Society of Antiquaries of London (1110); the University of Newcastle upon Tyne (photographer G. Finch) (430–2, 434–6, 471–3, 505, 514–17, 518–19, 521, 808–11, 821–45, 849–52, 856–63, 875–95, 1192–6, 1206–17, 1220–1, 1250–7, 1266–80, 1296–1301, 1322–4, 1370–1, 1376–8, 1406–13).

A NOTE ON REDUCTIONS

Whenever possible, the photographs have been reduced so that the stones are shown at one eighth of their actual size. This scale is not indicated in the captions. Views of details of larger stones, and small stones (normally those with dimensions not greater than 20 cm (8 in)) are shown at one fifth or, if exceptionally small, at one half of their actual size. These are marked respectively (1:5) and (1:2) in the captions. Stones which are either too large to be reproduced at one eighth of actual size, or the dimensions of which are unobtainable, have not been reduced according to any fixed scale, and are therefore marked in the captions as not to scale (nts).

LIST OF PLATES

PLATES 1–155
COUNTY DURHAM

Plate 1 **1** Auckland St Andrew 1a–dA (nts): **2** Auckland St Andrew 1a–dB (nts).

Plate 2 **3** Auckland St Andrew 1a–dC (nts): **4** Auckland St Andrew 1a–dD (nts).

Plate 3 **5** Auckland St Andrew 1bA: **6** Auckland St Andrew 1bA (1:5): **7** Auckland St Andrew 1aA (nts).

Plate 4 **8** Auckland St Andrew 1bB: **9** Auckland St Andrew 1bC: **10** Auckland St Andrew 1dB: **11** Auckland St Andrew 1aB/F (nts).

Plate 5 **12** Auckland St Andrew 1b–cD: **13** Auckland St Andrew 1dD: **14** Auckland St Andrew 1bD: **15** Auckland St Andrew 1dA.

Plate 6 **16** Auckland St Andrew 2: **17** Auckland St Andrew 3A: **18** Auckland St Andrew 4A: **19** Auckland St Andrew 4B: **20** Auckland St Andrew 4D: **21** Aycliffe 9A: **22** Aycliffe 9B: **23** Aycliffe 9C: **24** Aycliffe 9D.

Plate 7 **25** Aycliffe 1A: **26** Aycliffe 1B.

Plate 8 **27** Aycliffe 1C: **28** Aycliffe 1D.

Plate 9 **29** Aycliffe 2A: **30** Aycliffe 2B.

Plate 10 **31** Aycliffe 2C: **32** Aycliffe 2D.

Plate 11 **33** Aycliffe 3A: **34** Aycliffe 4A (1:5): **35** Aycliffe 5A: **36** Aycliffe 5D: **37** Aycliffe 5C: **38** Aycliffe 5B.

Plate 12 **39** Aycliffe 6A: **40** Aycliffe 6B: **41** Aycliffe 6C: **42** Aycliffe 6D: **43** Aycliffe 7A: **44** Aycliffe 7B: **45** Aycliffe 7C: **46** Aycliffe 7D: **47** Aycliffe 8A: **48** Aycliffe 8A/E: **49** Aycliffe 8C/E.

Plate 13 **50** Aycliffe 10A (1:5): **51** Aycliffe 10B (1:5): **52** Aycliffe 10C (1:5): **53** Aycliffe 10D (1:5): **54** Aycliffe 14: **55** Aycliffe 11A: **56** Aycliffe 11B.

Plate 14 **57** Aycliffe 12A: **58** Aycliffe 12B/E: **59** Aycliffe 12C: **60** Aycliffe 12D/E: **61** Aycliffe 13A: **62** Aycliffe 13B/E: **63** Aycliffe 13C: **64** Aycliffe 13D/E: **65** Aycliffe 16A: **66** Aycliffe 17.

Plate 15 **67** Aycliffe 15?A: **68** Billingham 1?A (nts): **69** Billingham 1A (after Stuart 1867): **70** Billingham 3B (after Stuart 1867): **71** Billingham 4 (after Stuart 1867): **72** Billingham 5B (after Stuart 1867).

Plate 16 **73** Billingham 2 (nts): **74** Billingham 2 (after Stuart 1867): **75** Billingham 6B (after Stuart 1867): **76** Billingham 7 (nts): **77** Billingham 8 (nts).

Plate 17 **78** Billingham 9A (nts): **79** Billingham 10 (nts): **80** Billingham 11 (nts): **81** Billingham 12A: **82** Billingham 12B: **83** Billingham 12C: **84** Billingham 12D: **85** Billingham 13A (1:5): **86** Billingham 13D (1:5): **87** Billingham 13C (1:5): **88** Billingham 16.

Plate 18 **89** Billingham 14A: **90** Billingham 14A/B: **91** Billingham 14C: **92** Billingham 15A: **93** Billingham 15A/B: **94** Chester-le-Street 5A: **95** Chester-le-Street 5B: **96** Chester-le-Street 5C: **97** Chester-le-Street 5D.

Plate 19 **98** Bishopwearmouth 1C: **99** Bishopwearmouth 1D: **100** Bishopwearmouth 1A: **101** Bishopwearmouth 1B.

Plate 20 **102** Chester-le-Street 1A: **103** Chester-le-Street 1B: **104** Chester-le-Street 6A: **105** Chester-le-Street 6B.

Plate 21 **106** Chester-le-Street 1C: **107** Chester-le-Street 1D: **108** Chester-le-Street 6C: **109** Chester-le-Street 6D.

Plate 22 **110** Chester-le-Street 2A: **111** Chester-le-Street 2B: **112** Chester-le-Street 4A: **113** Chester-le-Street 4B.

Plate 23 **114** Chester-le-Street 2C: **115** Chester-le-Street 2D: **116** Chester-le-Street 4C: **117** Chester-le-Street 4D.

Plate 24 **118** Chester-le-Street 3A (after Stuart 1867): **119** Chester-le-Street 3B (after Stuart 1867): **120** Chester-le-Street 3C (after Stuart 1867): **121** Chester-le-Street 3D (after Stuart 1867): **122** Chester-le-Street 7A (nts): **123** Chester-le-Street 7B (nts): **124** Chester-le-Street 7C (nts): **125** Chester-le-Street 7D (nts): **126** Chester-le-Street 8A: **127** Chester-le-Street 8B: **128** Chester-le-Street 8C: **129** Chester-le-Street 8D.

Plate 25 **130** Chester-le-Street 9A: **131** Chester-le-Street 9B: **132** Chester-le-Street 9C: **133** Chester-le-

Plate 142 **759** Sockburn 16A (nts): **760** Sockburn 16C (nts).

Plate 143 **761** Sockburn 17A: **762** Sockburn 17C.

Plate 144 **763** Sockburn 18A: **764** Sockburn 18C.

Plate 145 **765** Sockburn 20A (nts): **766** Sockburn 20C (nts).

Plate 146 **767** Sockburn 21A (nts): **768** Sockburn 21C (nts).

Plate 147 **769** Staindrop 1A: **770** Winston 1E: **771** Winston 1F: **772** Winston 1A: **773** Winston 1B: **774** Winston 1C: **775** Winston 1D.

Plate 148 **776** Unknown Provenance 1A: **777** Unknown Provenance 1B: **778** Unknown Provenance 2A: **779** Unknown Provenance 2B: **780** Unknown Provenance 2C: **781** Unknown Provenance 2D.

Plate 149 **782** Unknown Provenance 1C: **783** Unknown Provenance 1D: **784** Darlington 5A (nts): **785** Darlington 5A/B (nts).

Plate 150 **786** Dinsdale 11A/B/C: **787** Durham 15A: **788** Durham 15B: **789** Durham 15C: **790** Dinsdale 15D.

Plate 151 **791** Dinsdale 12: **792** Egglescliffe 3A: **793** Sockburn 24 (1:5): **794** Gainford 32A: **795** Dalton-le-Dale 2 (nts).

Plate 152 **796** Gainford 33A: **797** Monkwearmouth 30A.

Plate 153 **798** Sockburn 25A/B: **799** Sockburn 25B/F.

Plate 154 **800** Hartlepool 9D/A (after Ventress 1901–2, nts): **801** Sockburn 25D.

Plate 155 **802** Hart 12 (nts): **803** Pittington 1 (nts): **804** Darlington 6A: **805** Darlington 6B/C: **806** Darlington 6C: **807** Middleton One Row 1 (nts).

PLATES 156–259
NORTHUMBERLAND

Plate 156 **808** Alnmouth 1A (1:5): **809** Alnmouth 1B (1:5).

Plate 157 **810** Alnmouth 1C (1:5): **811** Alnmouth 1D (1:5).

Plate 158 **812** Bamburgh 1D/A/E: **813** Bamburgh 1D: **814** Bamburgh 1A: **815** Bamburgh 1C: **816** Bamburgh 1E: **817** Bamburgh 1B: **818** Birtley 1: **819** Birtley 2A (1:5).

Plate 159 **820** Bedlington 1: **821** Bothal 1A: **822** Bothal 1B: **823** Bothal 1C: **824** Bothal 2A: **825** Bothal 2B: **826** Bothal 2C: **827** Bothal 2D: **828** Bothal 3A: **829** Bothal 3B

Plate 160 **830** Bothal 3C: **831** Bothal 3D: **832** Bothal 4A: **833** Bothal 4B: **834** Bothal 4C: **835** Bothal 4D: **836** Bothal 5A: **837** Bothal 5D/E: **838** Bothal 5B/E: **839** Bothal 5C: **840** Bothal 5B/D/E.

Plate 161 **841** Bothal 6A: **842** Bothal 6D/E: **843** Bothal 6E: **844** Bothal 6C: **845** Bothal 6B/E: **846** Bothal 7: **847** Bywell 2B: **848** Bywell 2A: **849** Carham 3A: **850** Carham 3B: **851** Carham 3F: **852** Carham 3C/D.

Plate 162 **853** Bywell 1A: **854** Bywell 1D: **855** Bywell 1C: **856** Carham 1D/A: **857** Carham 1B.

Plate 163 **858** Carham 1C: **859** Carham 2F (nts): **860** Carham 2A: **861** Carham 2B: **862** Carham 2C: **863** Carham 2D.

Plate 164 **864** Coquet Island 1A (1:5): **865** Coquet Island 1D/A (1:5): **866** Coquet Island 1C (1:5): **867** Edlingham 1C: **868** Edlingham 1A: **869** Edlingham 1B: **870** Edlingham 1D: **871** Great Farne Island 1A: **872** Great Farne Island 1B: **873** Great Farne Island 1C: **874** Great Farne Island 1D.

Plate 165 **875** Falstone 1aA: **876** Falstone 1aB: **877** Falstone 1aC: **878** Falstone 1aD: **879** Falstone 1bA: **880** Falstone 1bB: **881** Falstone 1bC: **882** Falstone 1bD: **883** Falstone 1bE: **884** Falstone 1cA (1:5): **885** Falstone 1cB (1:5): **886** Falstone 1cC (1:5): **887** Falstone 1cD/A (1:5): **888** Falstone 1cE (1:5).

Plate 166 **889** Falstone 2A (1:5): **890** Falstone 2A (1:5): **891** Falstone 2A (1:5): **892** Falstone 2C (1:5): **893** Falstone 2B (1:5): **894** Falstone 2D (1:5): **895** Falstone 2F (1:5).

Plate 167 **896** Hexham 1a–dA (nts): **897** Hexham 1a–dB (nts).

Plate 168 **898** Hexham 1a–dC (nts): **899** Hexham 1a–dD (nts).

Plate 169 **900** Hexham 1a–bA: **901** Hexham 1a–bB: **902** Hexham 1a–bC: **903** Hexham 1a–bD: **904** Hexham 1dB (1:5).

PLATES 260–267
COMPARATIVE MATERIAL

PLATES 1–155

COUNTY DURHAM

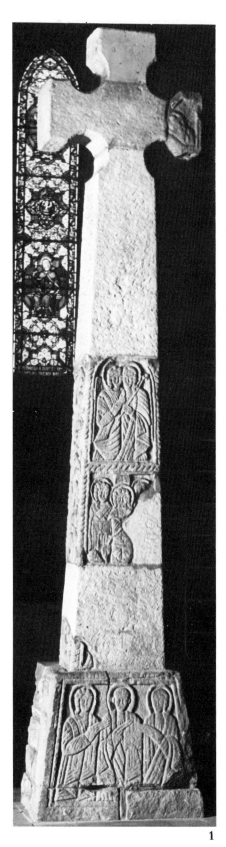

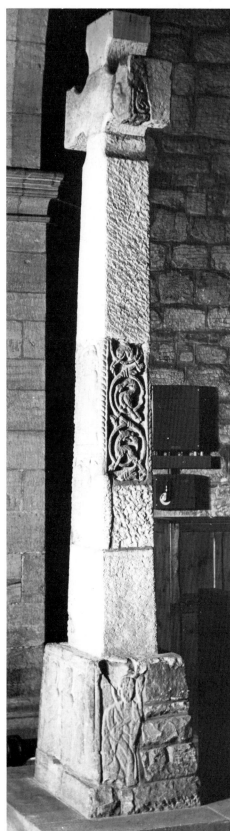

1

2

Plate 1 **1** Auckland St Andrew 1a–dA (nts): **2** Auckland St Andrew 1a–dB (nts).

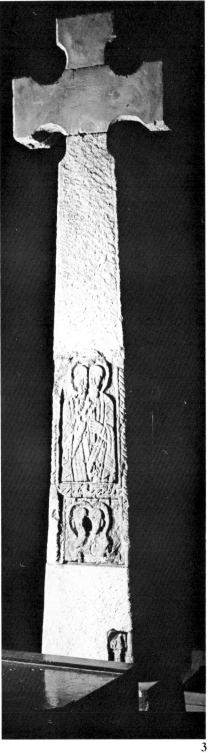

3

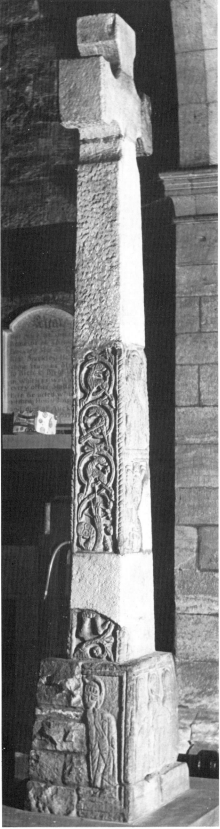

4

Plate 2 **3** Auckland St Andrew 1a–dC (nts): **4** Auckland St Andrew 1a–dD (nts).

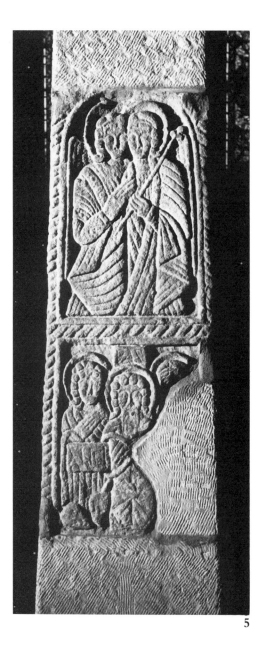

5

6

7

Plate 3　**5** Auckland St Andrew 1bA: **6** Auckland St Andrew 1bA (1:5): **7** Auckland St Andrew 1aA (nts).

8

9

10

11

Plate 4 **8** Auckland St Andrew 1bB: **9** Auckland St Andrew 1bC:
10 Auckland St Andrew 1dB: **11** Auckland St Andrew 1aB/F (nts).

12

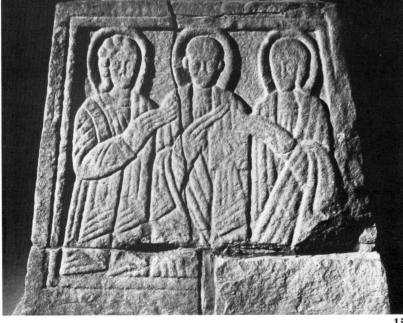

13

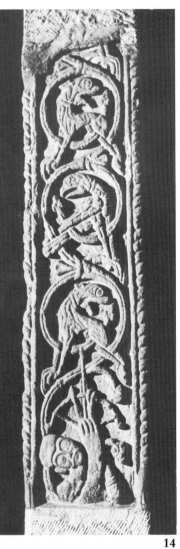

14

15

Plate 5 **12** Auckland St Andrew 1b–cD:
13 Auckland St Andrew 1dD: **14** Auckland
St Andrew 1bD: **15** Auckland St Andrew
1dA.

16

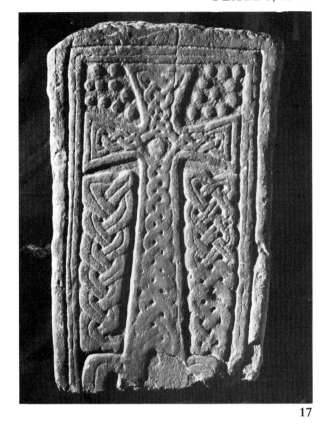

17

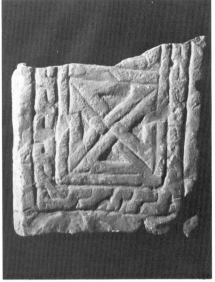

18

21 22

19 20 23 24

Plate 6 **16** Auckland St Andrew 2: **17** Auckland St Andrew 3A: **18**
Auckland St Andrew 4A: **19** Auckland St Andrew 4B: **20** Auckland
St Andrew 4D: **21** Aycliffe 9A: **22** Aycliffe 9B: **23** Aycliffe 9C: **24**
Aycliffe 9D.

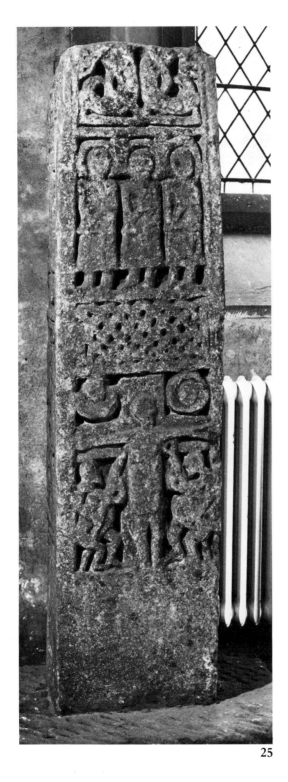

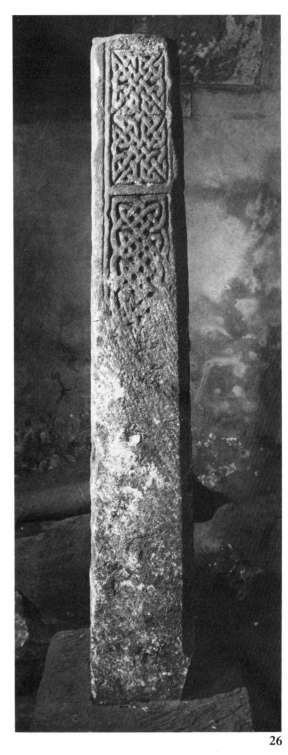

25

26

Plate 7 **25** Aycliffe 1A: **26** Aycliffe 1B.

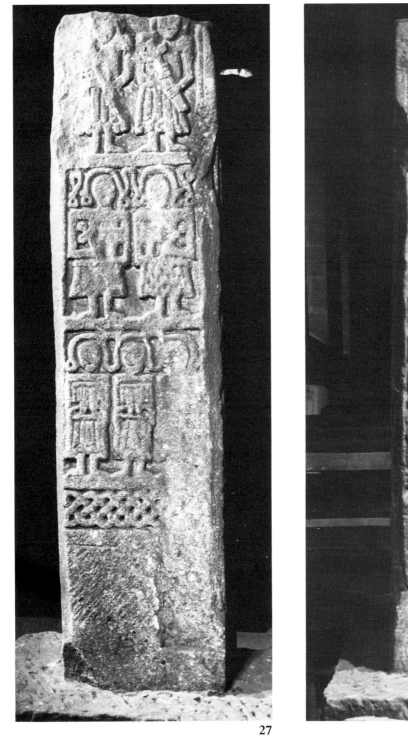

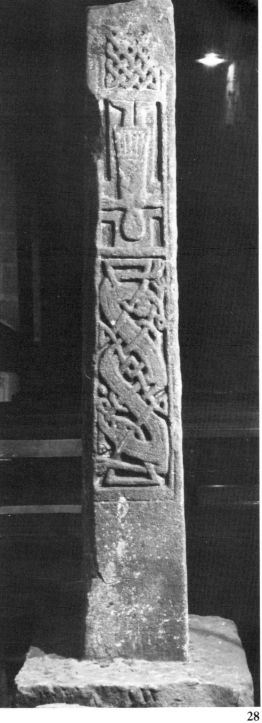

27

28

Plate 8 **27** Aycliffe 1C: **28** Aycliffe 1D.

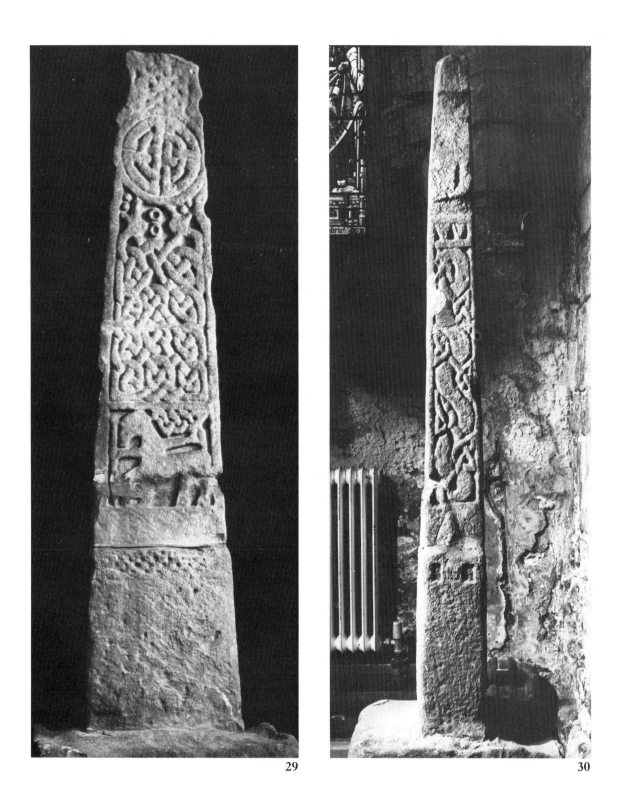

29

30

Plate 9 **29** Aycliffe 2A: **30** Aycliffe 2B.

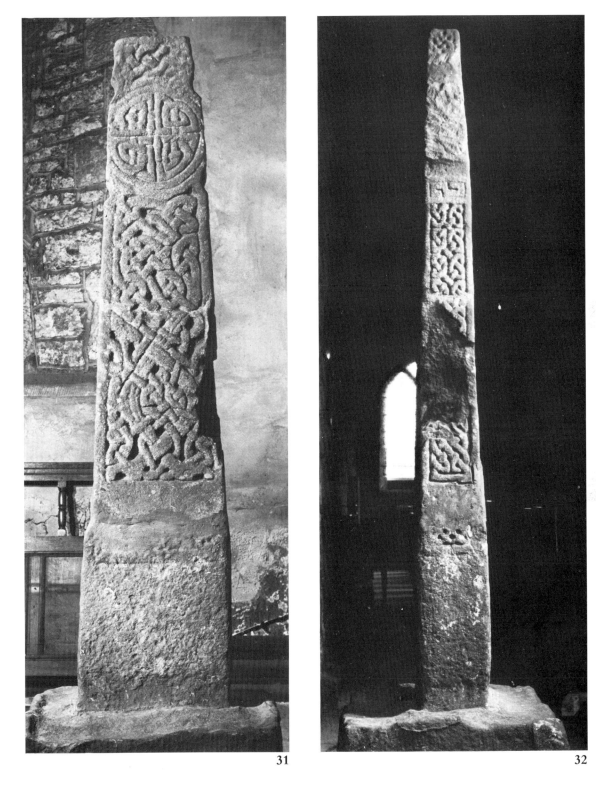

31 32

Plate 10 **31** Aycliffe 2C: **32** Aycliffe 2D.

33

34

35

36

37

38

Plate 11 **33** Aycliffe 3A: **34** Aycliffe 4A (1:5): **35** Aycliffe 5A: **36** Aycliffe 5D: **37** Aycliffe 5C: **38** Aycliffe 5B.

39 40 41 42

43 44 45 46

47

48

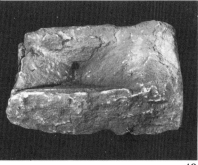

49

Plate 12 **39** Aycliffe 6A: **40** Aycliffe 6B: **41** Aycliffe 6C: **42** Aycliffe 6D: **43** Aycliffe 7A: **44** Aycliffe 7B: **45** Aycliffe 7C: **46** Aycliffe 7D: **47** Aycliffe 8A: **48** Aycliffe 8A/E: **49** Aycliffe 8C/E.

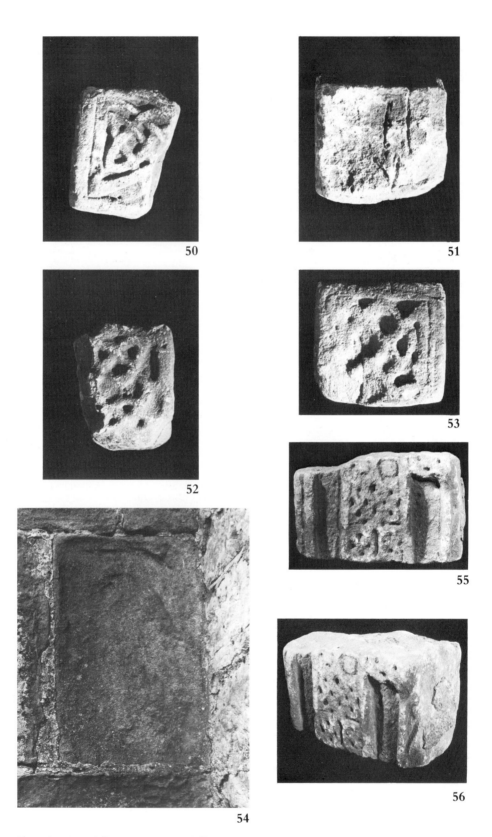

Plate 13 **50** Aycliffe 10A (1:5): **51** Aycliffe 10B (1:5): **52** Aycliffe 10C (1:5): **53** Aycliffe 10D (1:5): **54** Aycliffe 14: **55** Aycliffe 11A: **56** Aycliffe 11B.

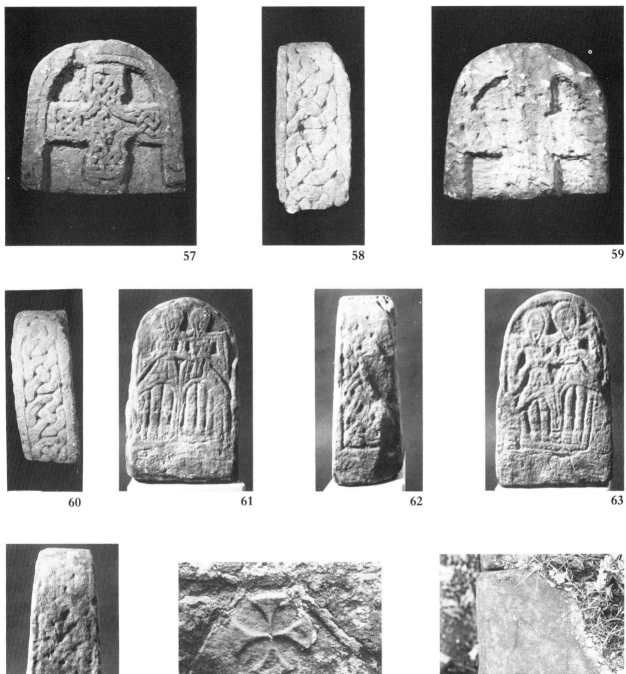

57 58 59

60 61 62 63

64 65 66

Plate 14 **57** Aycliffe 12A: **58** Aycliffe 12B/E: **59** Aycliffe 12C: **60**
Aycliffe 12D/E: **61** Aycliffe 13A: **62** Aycliffe 13B/E: **63** Aycliffe
13C: **64** Aycliffe 13D/E: **65** Aycliffe 16A: **66** Aycliffe 17.

68

69

70

71

72

67

Plate 15 **67** Aycliffe 15?A: **68** Billingham 1?A (nts): **69** Billingham 1A (after Stuart 1867): **70** Billingham 3B (after Stuart 1867): **71** Billingham 4 (after Stuart 1867): **72** Billingham 5B (after Stuart 1867).

73 74 75

76 77

Plate 16 **73** Billingham 2 (nts): **74** Billingham 2 (after Stuart 1867):
75 Billingham 6B (after Stuart 1867): **76** Billingham 7 (nts): **77**
Billingham 8 (nts).

Plate 17 **78** Billingham 9A (nts): **79** Billingham 10 (nts): **80** Billing-
ham 11 (nts): **81** Billingham 12A: **82** Billingham 12B: **83** Billing-
ham 12C: **84** Billingham 12D: **85** Billingham 13A (1:5): **86** Billing-
ham 13D (1:5): **87** Billingham 13C (1:5): **88** Billingham 16.

89

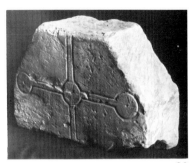
90

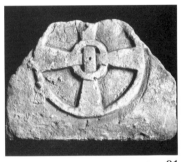
91

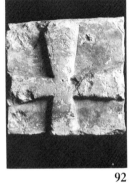
92

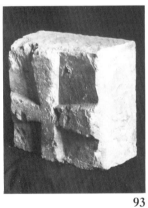
93

94

95

96

97

Plate 18 **89** Billingham 14A: **90** Billingham 14A/B: **91** Billingham
14C: **92** Billingham 15A: **93** Billingham 15A/B: **94** Chester-le-
Street 5A: **95** Chester-le-Street 5B: **96** Chester-le-Street 5C: **97**
Chester-le-Street 5D.

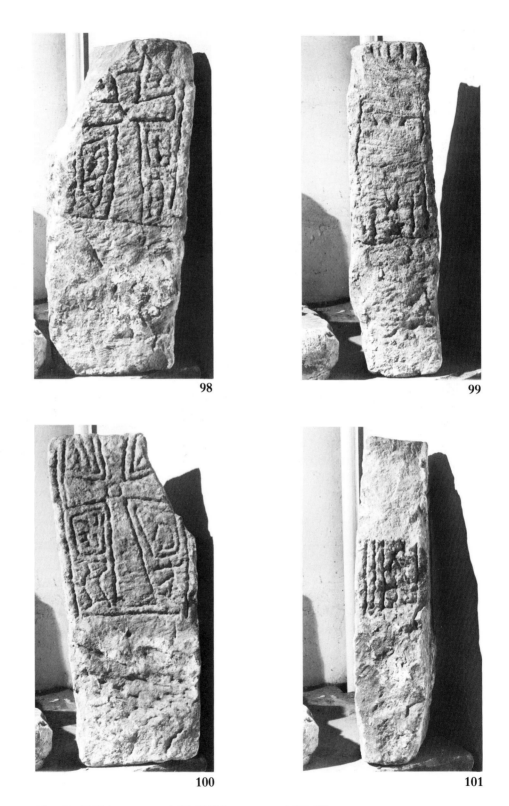

98

99

100

101

Plate 19 **98** Bishopwearmouth 1C: **99** Bishopwearmouth 1D: **100** Bishopwearmouth 1A: **101** Bishopwearmouth 1B.

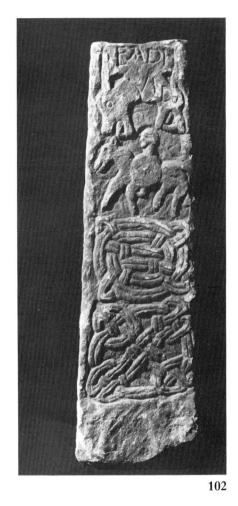

102

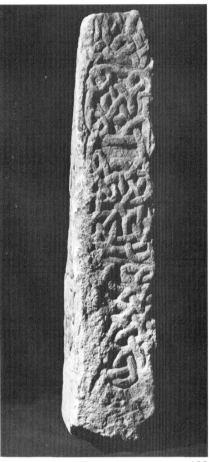

103

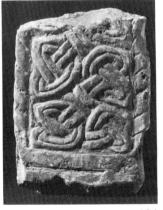

104

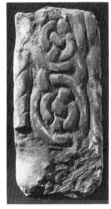

105

Plate 20 **102** Chester-le-Street 1A: **103** Chester-le-Street 1B: **104** Chester-le-Street 6A: **105** Chester-le-Street 6B.

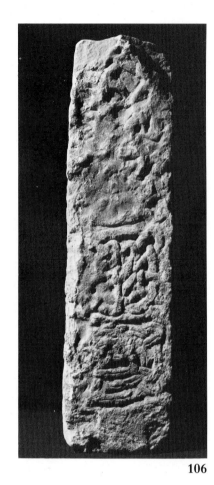

106

107

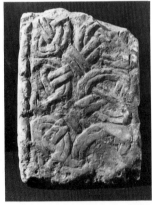

108

109

Plate 21 **106** Chester-le-Street 1C: **107** Chester-le-Street 1D: **108** Chester-le-Street 6C; **109** Chester-le-Street 6D.

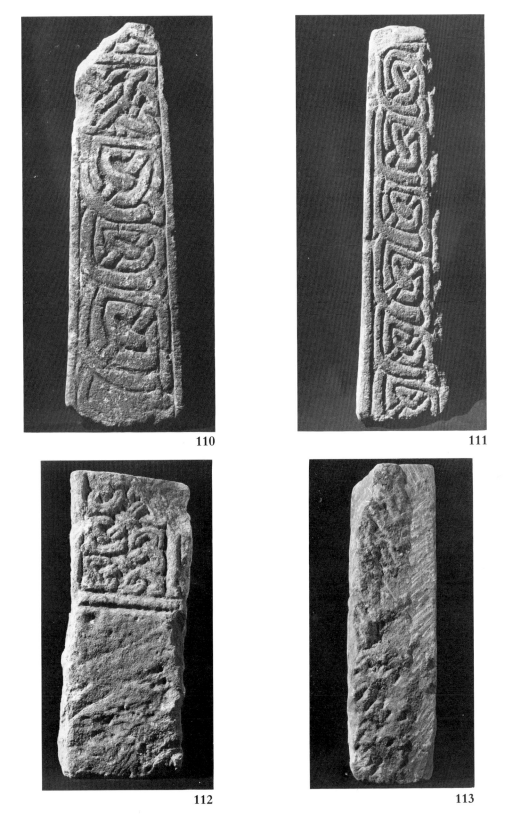

110

111

112

113

Plate 22 **110** Chester-le-Street 2A: **111** Chester-le-Street 2B: **112**
Chester-le-Street 4A: **113** Chester-le-Street 4B.

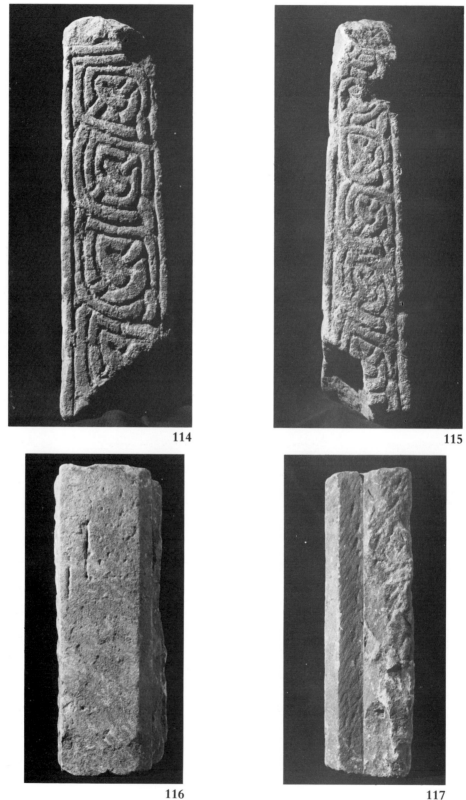

114

115

116

117

Plate 23 **114** Chester-le-Street 2C: **115** Chester-le-Street 2D: **116**
Chester-le-Street 4C: **117** Chester-le-Street 4D.

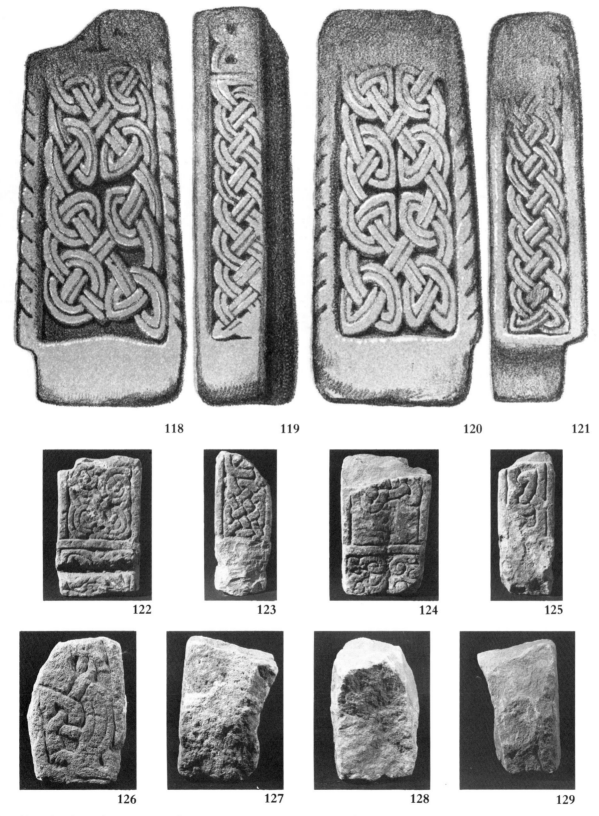

118 119 120 121

122 123 124 125

126 127 128 129

Plate 24 **118** Chester-le-Street 3A (after Stuart 1867): **119** Chester-le-Street 3B (after Stuart 1867): **120** Chester-le-Street 3C (after Stuart 1867): **121** Chester-le-Street 3D (after Stuart 1867): **122** Chester-le-Street 7A (nts): **123** Chester-le-Street 7B (nts): **124** Chester-le-Street 7C (nts): **125** Chester-le-Street 7D (nts): **126** Chester-le-Street 8A: **127** Chester-le-Street 8B: **128** Chester-le-Street 8C: **129** Chester-le-Street 8D.

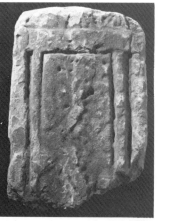
130

131

132

133

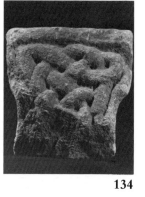
134

135

136

137

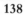
138

Plate 25 **130** Chester-le-Street 9A: **131** Chester-le-Street 9B: **132** Chester-le-Street 9C: **133** Chester-le-Street 9D: **134** Chester-le-Street 10A: **135** Chester-le-Street 10B: **136** Chester-le-Street 10C: **137** Chester-le-Street 10D: **138** Chester-le-Street 10E.

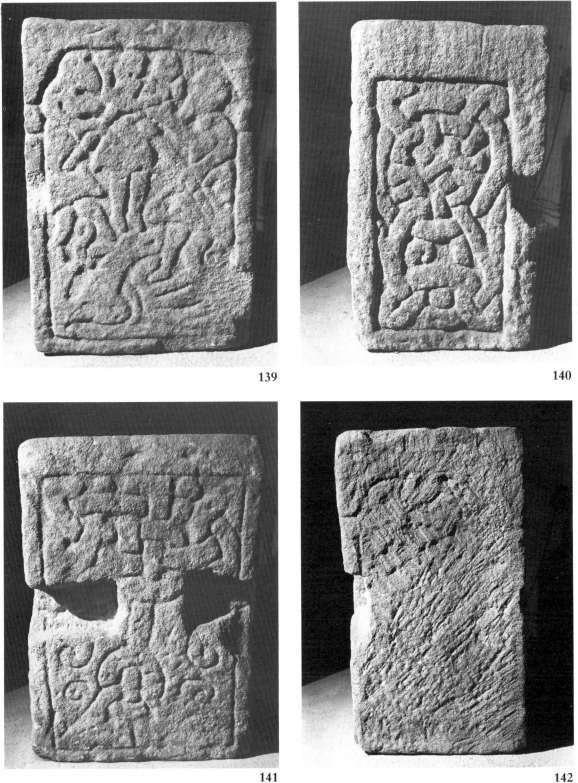

139

140

141

142

Plate 26 **139** Chester-le-Street 11A: **140** Chester-le-Street 11B: **141** Chester-le-Street 11C: **142** Chester-le-Street 11D.

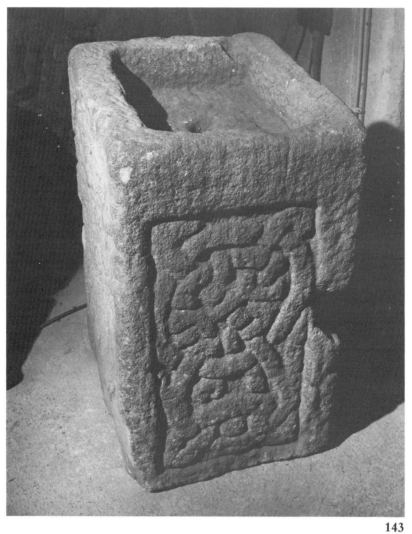

143

144

145

146

Plate 27 **143** Chester-le-Street 11A/E: **144** Chester-le-Street 13A:
145 Chester-le-Street 13B: **146** Chester-le-Street 13F.

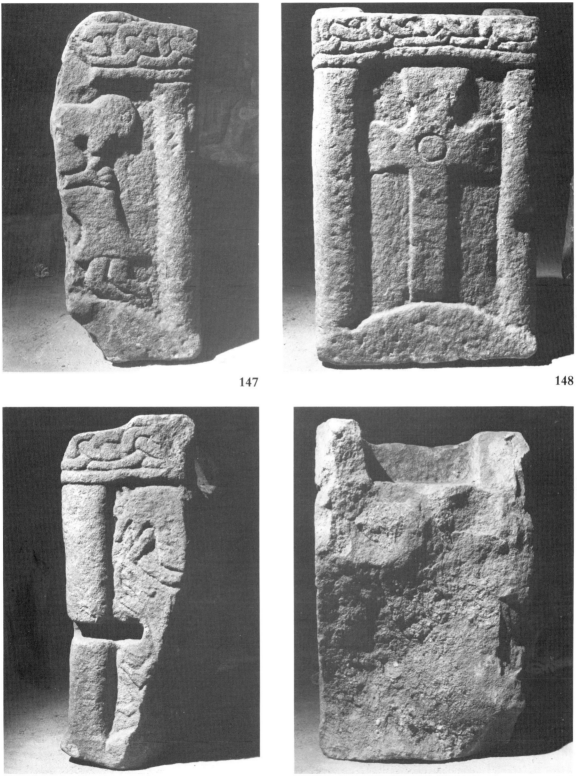

147

148

149

150

Plate 28 **147** Chester-le-Street 12A: **148** Chester-le-Street 12B: **149** Chester-le-Street 12C: **150** Chester-le-Street 12D.

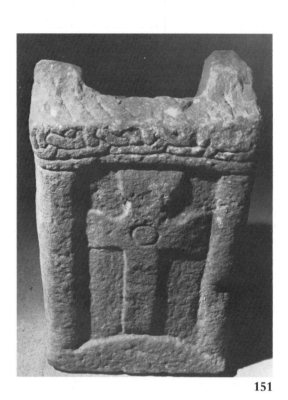

151

152

153

154

Plate 29 **151** Chester-le-Street 12A/E: **152** Coniscliffe 1 (1:5): **153**
Coniscliffe 2?B: **154** Coniscliffe 3.

155

157

156

158

159

Plate 30 **155** Coniscliffe 4 (nts): **156** Dalton-le-Dale 1?A (nts): **157** Coniscliffe 6: **158** Coniscliffe 5 (nts): **159** Coniscliffe 7 (nts).

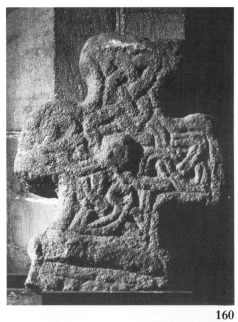

160

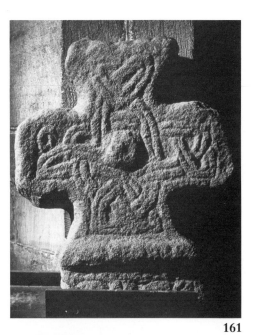

161

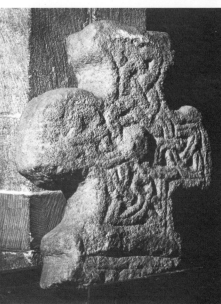

162

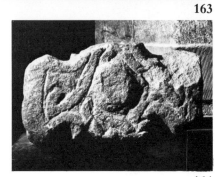

163

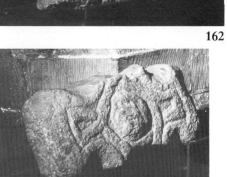

165

Plate 31 160 Darlington 1A: 161 Darlington 1C: 162 Darlington 1D/A: 163 Darlington 2A: 164 Darlington 2C: 165 Darlington 2D/A.

164

166

167

168

169

Plate 32 **166** Darlington 3A: **167** Darlington 4: **168** Darlington
3D/A: **169** Darlington 4.

Plate 33 **170** Dinsdale 1A: **171** Dinsdale 1B: **172** Dinsdale 4?B: **173** Dinsdale 5.

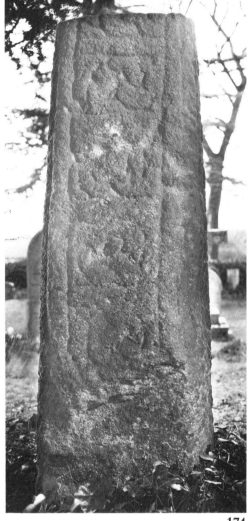

174

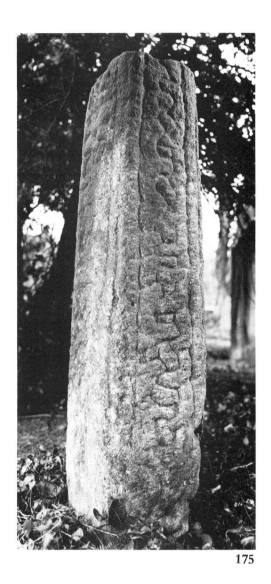

175

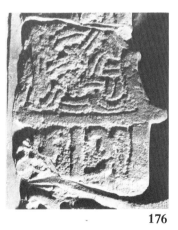

176

177

Plate 34 **174** Dinsdale 1C: **175** Dinsdale 1D: **176** Dinsdale 6A: **177**
Dinsdale 6B.

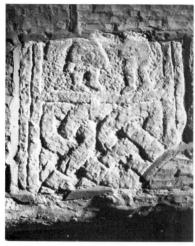

178

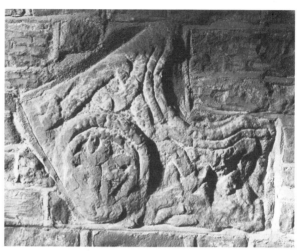

179

180

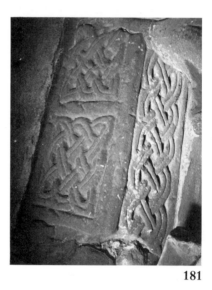

181

182

183

Plate 35 **178** Dinsdale 2A: **179** Dinsdale 7A: **180** Dinsdale 3A: **181** Dinsdale 3B: **182** Dinsdale 9A: **183** Dinsdale 10 (nts).

184

186

185

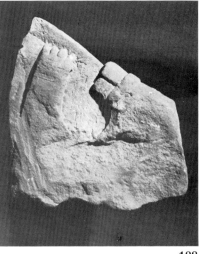

187

188

Plate 36 **184** Dinsdale 8bA: **185** Dinsdale 8bC: **186** Dinsdale 8a:
187 Dinsdale 8a: **188** Dinsdale 8a.

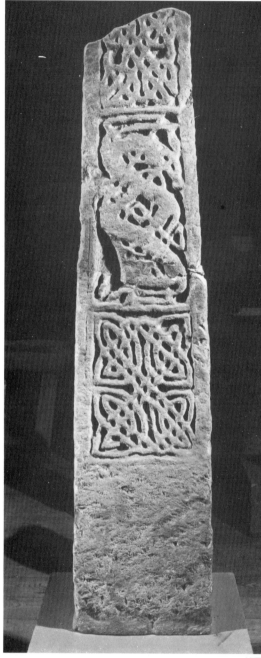

189

190

Plate 37 **189** Durham 1A: **190** Durham 1B.

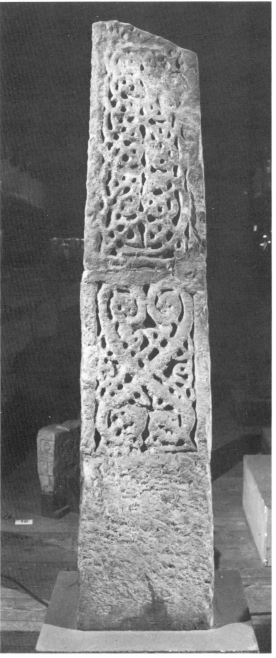

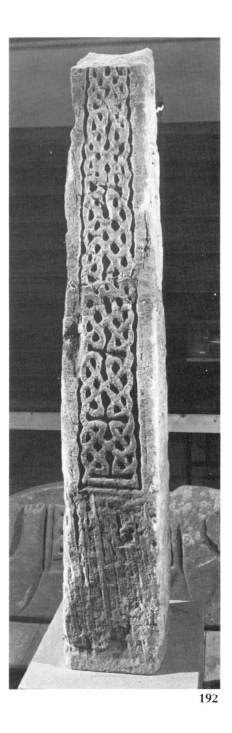

191

192

Plate 38 **191** Durham 1C: **192** Durham 1D.

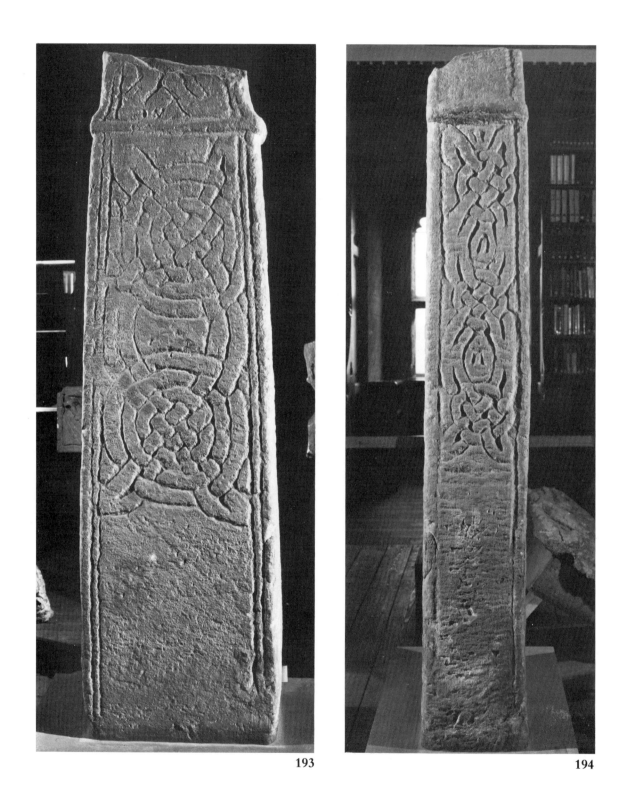

193

194

Plate 39 **193** Durham 2A: **194** Durham 2B.

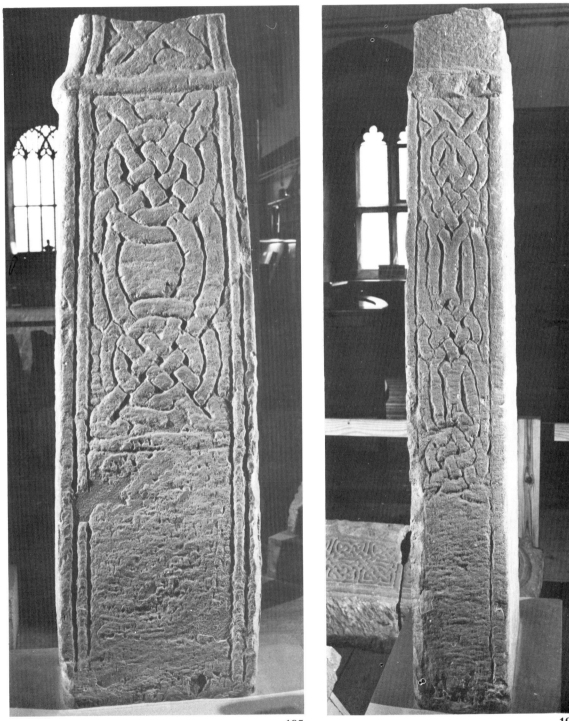

195 196

Plate 40 **195** Durham 2C: **196** Durham 2D.

197

198

Plate 41 **197** Durham 3A: **198** Durham 3B.

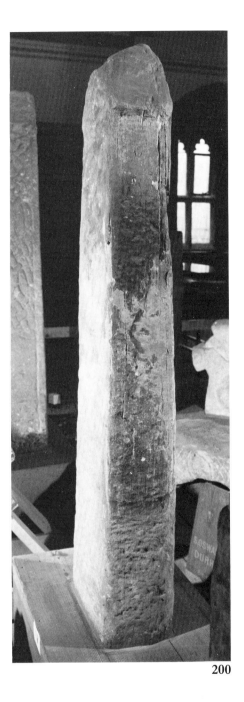

199

200

Plate 42 **199** Durham 3C: **200** Durham 3D.

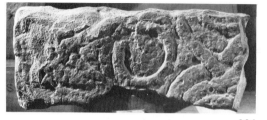

201

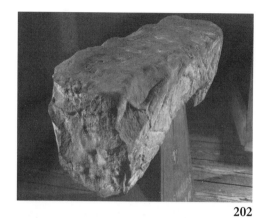

202

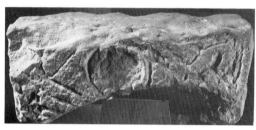

203

204

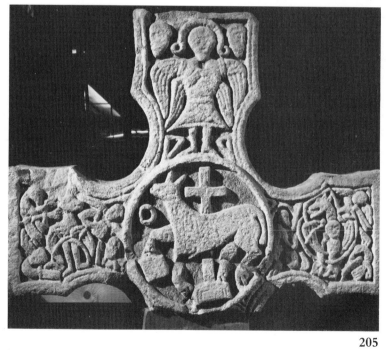

205

Plate 43 **201** Durham 4A: **202** Durham 4B/C/E: **203** Durham 4C:
204 Durham 4C/D/E: **205** Durham 5A.

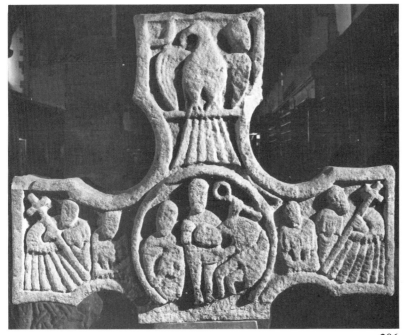

206

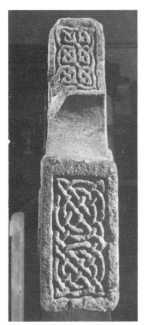

207

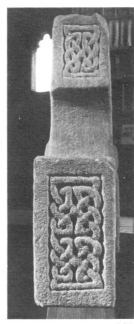

208

Plate 44 **206** Durham 5C: **207** Durham 5B: **208** Durham 5D.

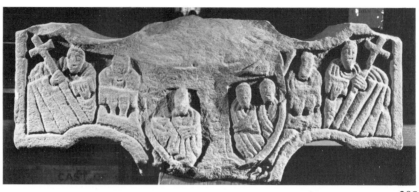

209

210

211 212

Plate 45 **209** Durham 6A: **210** Durham 6C: **211** Durham 6B: **212** Durham 6D.

213

214

215

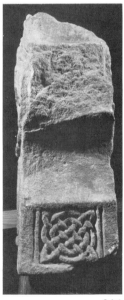

216

Plate 46　**213** Durham 7A: **214** Durham 7B: **215** Durham 7C: **216** Durham 7D.

217

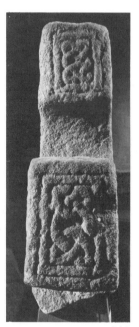

218

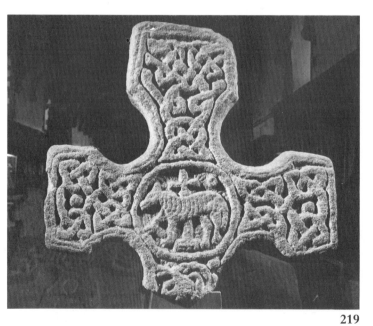

219

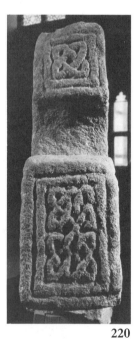

220

Plate 47 **217** Durham 8A: **218** Durham 8B: **219** Durham 8C: **220** Durham 8D.

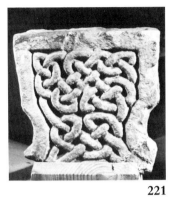

221

222

223

224

225

227

226

228

229

230

231

232

233

Plate 48 **221** Durham 9A (1:5): **222** Durham 9B (1:5): **223** Durham
9C (1:5): **224** Durham 9D (1:5): **225** Durham 9E (1:5): **226** Durham
10A (1:5): **227** Durham 10C (1:5): **228** Durham 10B (1:5): **229**
Durham 14D/A: **230** Durham 10D (1:5): **231** Durham 14A/B: **232**
Durham 14A: **233** Durham 10E (1:5).

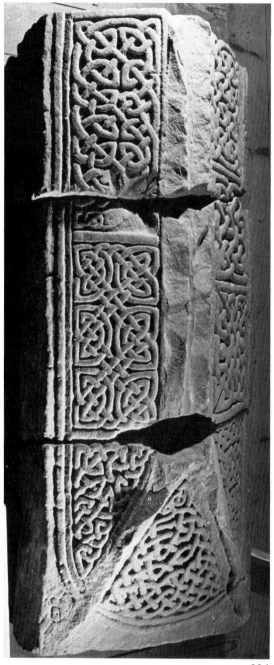

234

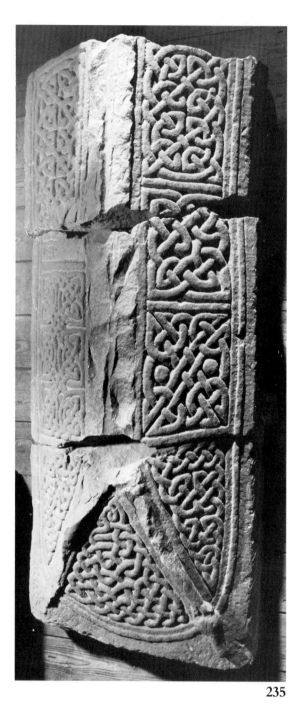

235

Plate 49 **234** Durham 11A/B: **235** Durham 11B/C.

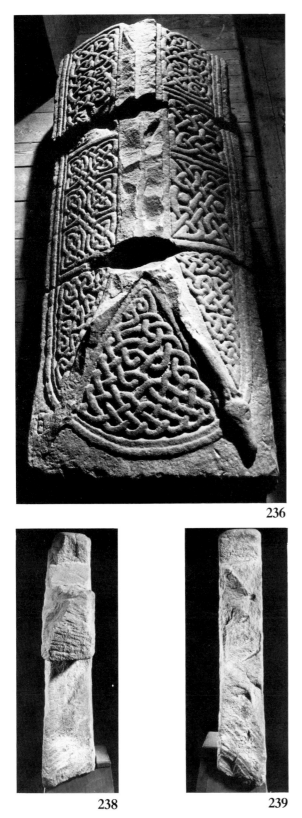

236

237

240

238

239

Plate 50　**236** Durham 11A/B/C: **237** Durham 13A: **238** Durham
13B: **239** Durham 13D: **240** Durham 13C.

241

242

243

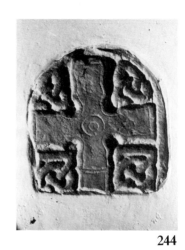

244

Plate 51 **241** Durham 12A: **242** Egglescliffe 1C: **243** Easington 1A:
244 Elwick Hall 2A (nts).

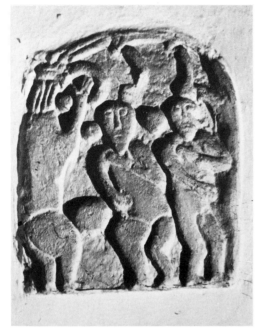

245

246

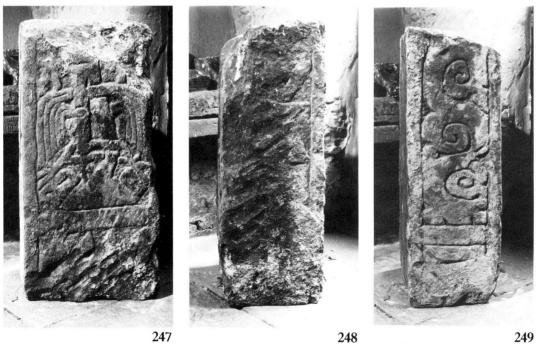

247 248 249

Plate 52 **245** Elwick Hall 1A (nts): **246** Egglescliffe 2A/E: **247** Egglescliffe 1A: **248** Egglescliffe 1B: **249** Egglescliffe 1D.

250

251

252

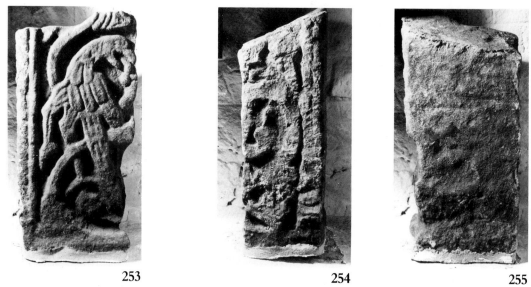

253

254

255

Plate 53 **250** Escomb 1aA: **251** Escomb 1aD: **252** Escomb 1bB: **253** Escomb 1bA: **254** Escomb 1bD: **255** Escomb 1bC.

256

257

258

259

260

261

262

265

263

264

Plate 54 **256** Escomb 2A (1:5): **257** Escomb 2B (1:5): **258** Escomb 2C (1:5): **259** Escomb 2D (1:5): **260** Escomb 3A (1:2): **261** Escomb 3B (1:2): **262** Escomb 3C (1:2): **263** Escomb 5A: **264** Escomb 5A/B: **265** Escomb 3C/A (1:2).

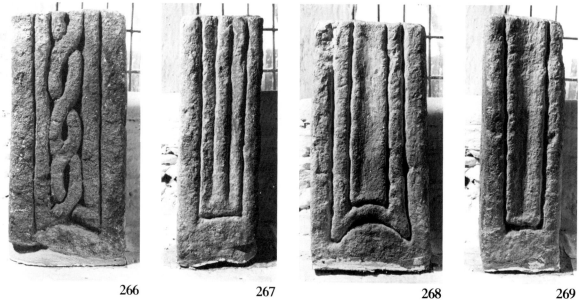

266 267 268 269

270 271 272

Plate 55 **266** Escomb 4A: **267** Escomb 4D: **268** Escomb 4C: **269** Escomb 4B: **270** Escomb 7A/B: **271** Escomb 7A: **272** Escomb 7D/A.

273

274

275

276

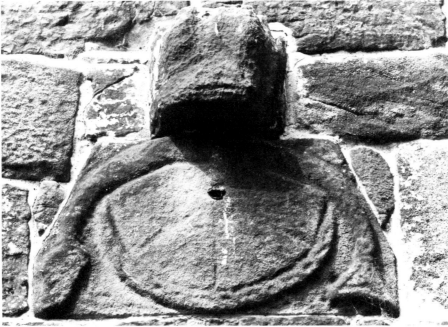

277

Plate 56 **273** Escomb 6A (1:5): **274** Escomb 6B (1:5): **275** Escomb 6D (1:5): **276** Escomb 6C (1:5): **277** Escomb 8a–b (nts).

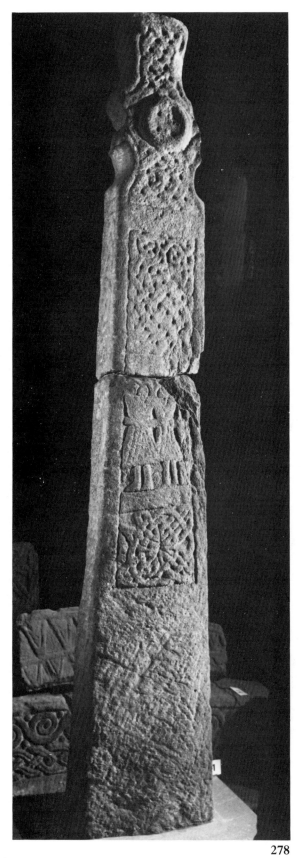

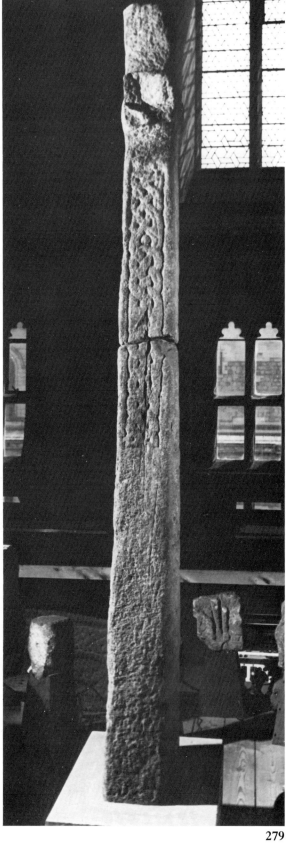

278

279

Plate 57 **278** Gainford 1A (nts): **279** Gainford 1B (nts).

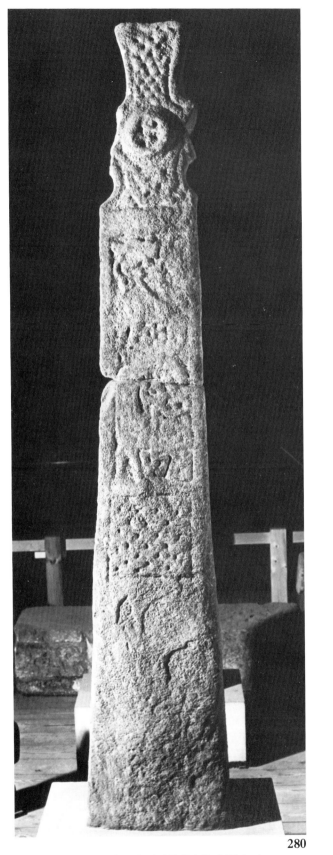

280

281

Plate 58 **280** Gainford 1C (nts): **281** Gainford 1D (nts).

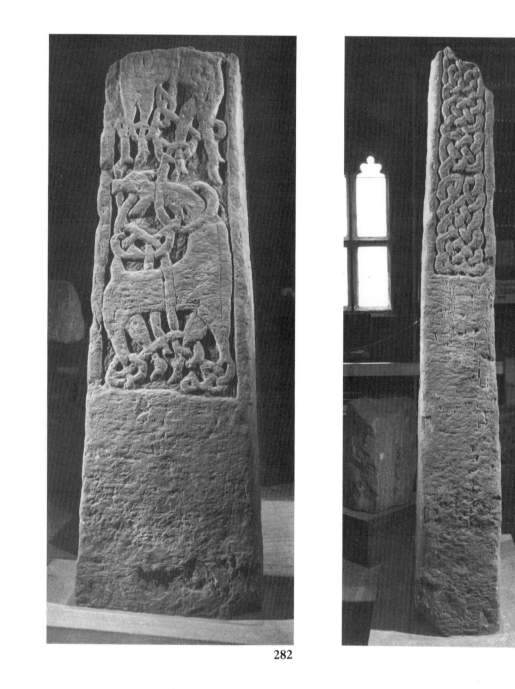

282

283

Plate 59 **282** Gainford 2A: **283** Gainford 2B.

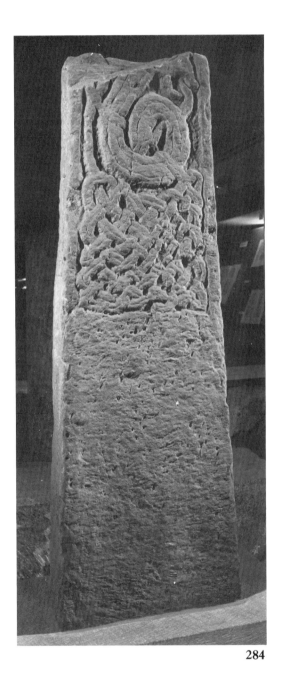

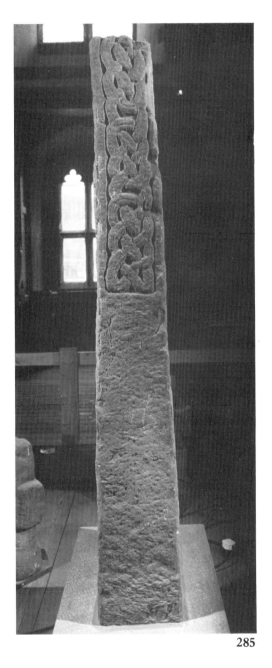

284

285

Plate 60 **284** Gainford 2C: **285** Gainford 2D.

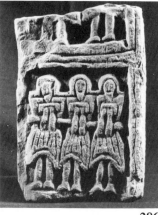

286

287

288

289

290

291

292

293

Plate 61 **286** Gainford 3A: **287** Gainford 3B: **288** Gainford 3C: **289**
Gainford 3D: **290** Gainford 4A: **291** Gainford 4B: **292** Gainford 4C:
293 Gainford 4D.

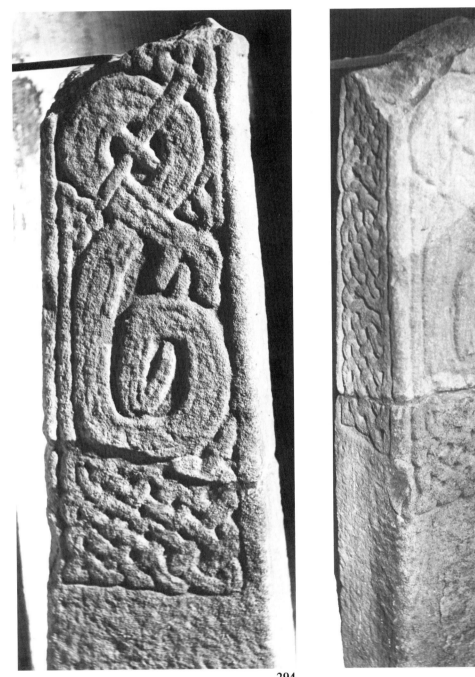

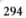

294

295

Plate 62 **294** Gainford 5A (nts): **295** Gainford 5D/A (nts).

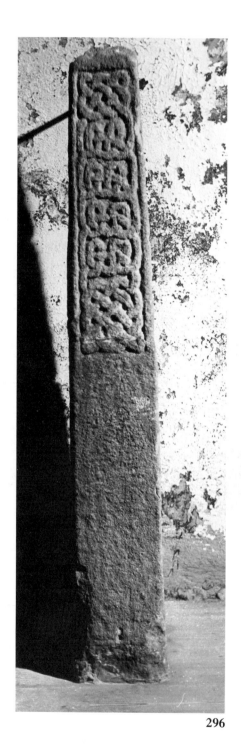

296

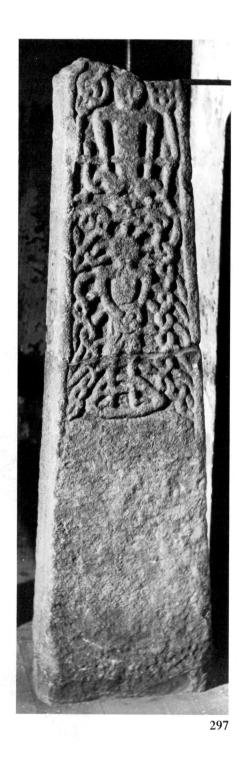

297

Plate 63 **296** Gainford 5B: **297** Gainford 5C.

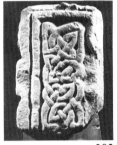

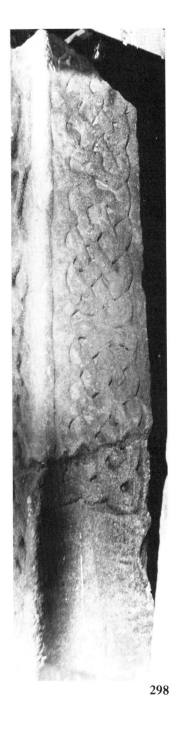

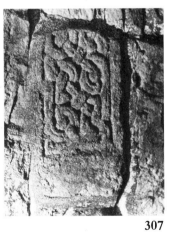

299

300

301

302

303

304

305

298

306

307

Plate 64 **298** Gainford 5D: **299** Gainford 6A: **300** Gainford 6B: **301**
Gainford 6D: **302** Gainford 6C: **303** Gainford 7A: **304** Gainford 7D:
305 Gainford 7C: **306** Gainford 7B: **307** Gainford 8.

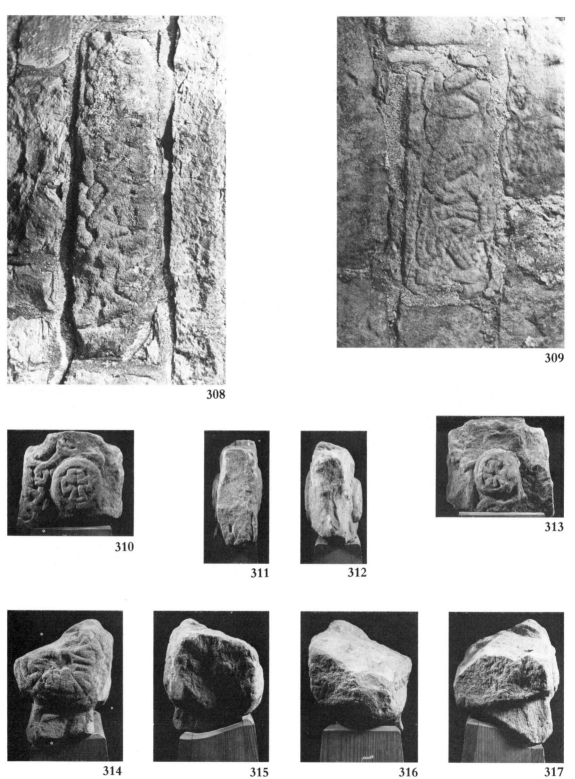

Plate 65 **308** Gainford 9B: **309** Gainford 10 (nts): **310** Gainford
13A: **311** Gainford 13B: **312** Gainford 13D: **313** Gainford 13C: **314**
Gainford 14A (1:5): **315** Gainford 14B (1:5): **316** Gainford 14C (1:5):
317 Gainford 14D (1:5).

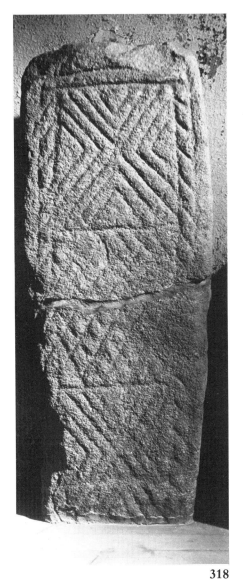

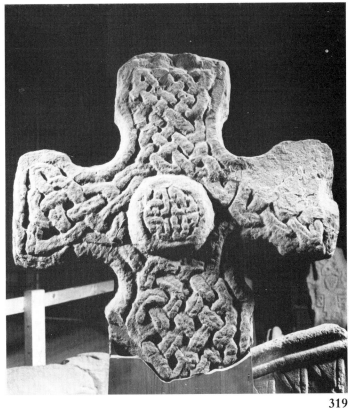

319

318

320 321

322 323

Plate 66 **318** Gainford 11A: **319** Gainford 12A: **320** Gainford 15A:
321 Gainford 15B: **322** Gainford 15C: **323** Gainford 15D.

Plate 67 **324** Gainford 12D: **325** Gainford 12C: **326** Gainford 12B:
327 Gainford 16A: **328** Gainford 16B: **329** Gainford 16C: **330** Gainford 16D.

331 332 333 334

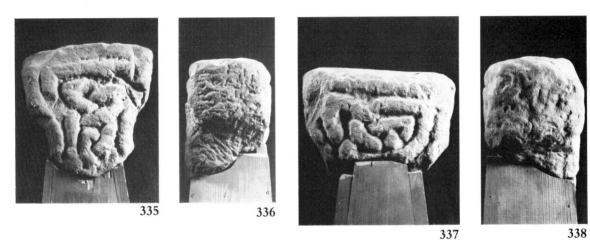

335 336 337 338

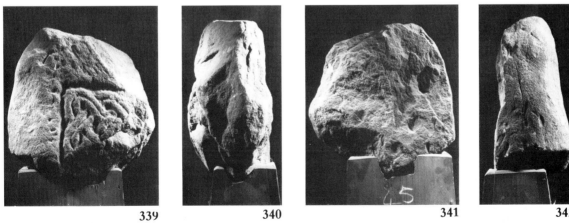

339 340 341 342

Plate 68 **331** Gainford 17A: **332** Gainford 17B: **333** Gainford 17C:
334 Gainford 17D: **335** Gainford 18A (1:5): **336** Gainford 18B (1:5):
337 Gainford 18C (1:5): **338** Gainford 18D (1:5): **339** Gainford 19A:
340 Gainford 19B: **341** Gainford 19F: **342** Gainford 19D.

343

344

345

346

347

348

Plate 69 343 Gainford 20A: 344 Gainford 20B: 345 Gainford 20D:
346 Gainford 20F: 347 Gainford 21A (1:5): 348 Gainford 21B (1:5).

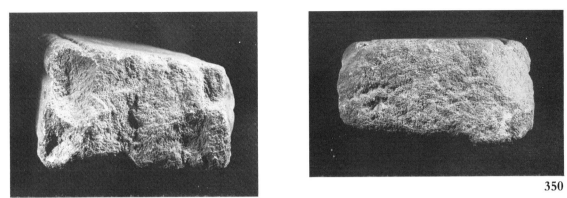

349

350

351

352

Plate 70 **349** Gainford 21C (1:5): **350** Gainford 21E (1:5): **351** Gainford 21D (1:5): **352** Gainford 21F (1:5).

353

354

Plate 71 **353** Gainford 22A: **354** Gainford 22C.

355

356

357

358

Plate 72 **355** Gainford 22D: **356** Gainford 23A: **357** Gainford 22B:
358 Gainford 23A/B/E.

359

360

Plate 73 **359** Gainford 23A/B/C: **360** Gainford 23A/D/E.

361

362

363

364

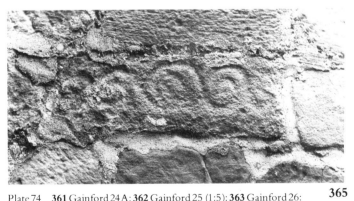

365

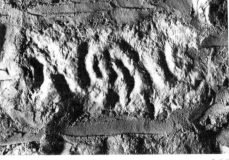

366

Plate 74 **361** Gainford 24 A: **362** Gainford 25 (1:5): **363** Gainford 26:
364 Gainford 27: **365** Gainford 28 A: **366** Gainford 29

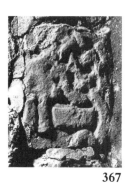

367

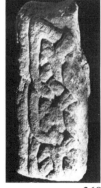

368

369

370

371

372

373

374

375

376

377

378

Plate 75 **367** Gainford 30: **368** Gainford 31A: **369** Gainford 31B: **370** Gainford 31C: **371** Gainford 31D: **372** Greatham 1A(1:5): **373** Greatham 1A/B (1:5): **374** Greatham 1C (1:5): **375** Greatham 2A (1:5): **376** Greatham 2B (1:5): **377** Greatham 2C (1:5): **378** Greatham 2D (1:5).

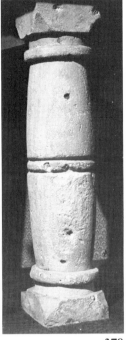

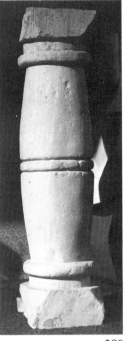

381

379

380

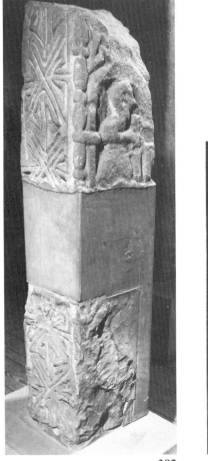

382

383

384

Plate 76 **379** Greatham 3a: **380** Greatham 3b: **381** Greatham 4 (1:5):
382 Great Stainton 1a–bD/A: **383** Great Stainton 1bA: **384** Great
Stainton 1a–bC.

387

385

386

388

389

390

Plate 77 **385** Great Stainton 1bB: **386** Great Stainton 1a–bD: **387**
Great Stainton 2A: **388** Great Stainton 2B: **389** Great Stainton 2C:
390 Great Stainton 2D.

391

393

392

Plate 78 **391** Great Stainton 3A/E: **392** Great Stainton 3D/A/E:
393 Great Stainton 3D/E.

394

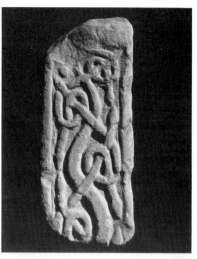

395

396

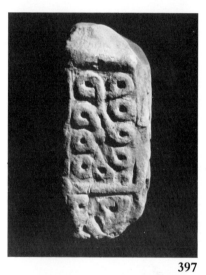

397

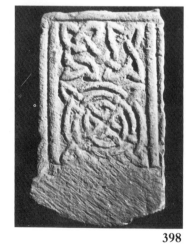

398

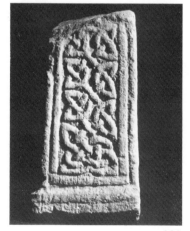

399

Plate 79 **394** Hart 1A: **395** Hart 1B: **396** Hart 1C: **397** Hart 1D: **398** Hart 2A: **399** Hart 2B.

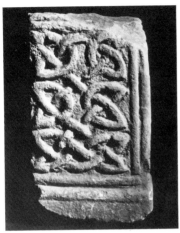

400

401

402

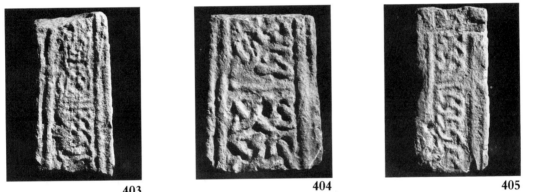

403

404

405

406

407

Plate 80 **400** Hart 2C: **401** Hart 2D: **402** Hart 4A: **403** Hart 4B: **404**
Hart 4C: **405** Hart 4D: **406** Hart 5A (1:5): **407** Hart 5B (1:5).

408

409

410

411

412

413

414

Plate 81 **408** Hart 5C (1:5): **409** Hart 5D (1:5): **410** Hart 3A (nts):
411 Hart 6A: **412** Hart 8D/A (1:5): **413** Hart 8A/B (1:5): **414** Hart 8A
(1:5).

415

416

417

418

419 420 421

Plate 82 **415** Hart 8C (1:5) **416** Hart 7B: **417** Hart 7A: **418**
Hart 7C: **419** Hart 10b: **420** Hart 10a: **421** Hart 11a

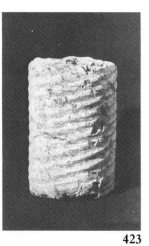

422

423

424

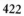

425

426

427

428

Plate 83 **422** Hart 11b: **423** Hart 11c (1:5): **424** Hart 11d: **425** Hart
9A (1:5): **426** Hart 9B (1:5): **427** Hart 9C (1:5): **428** Hart 9D (1:5).

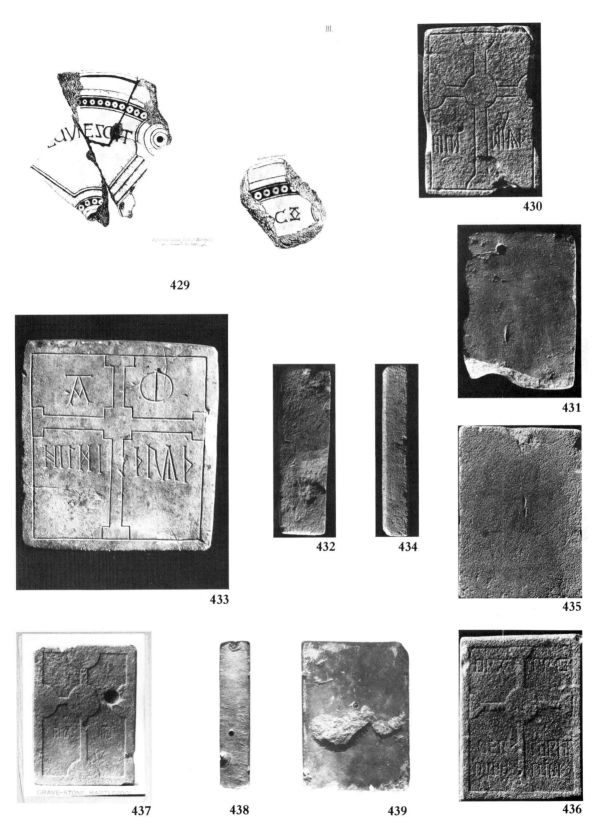

429

430

431

432

434

433

435

437

438

439

436

Plate 84 429 Hartlepool O (after Gage 1836, nts): 430 Hartlepool
2A (1:5): 431 Hartlepool 2C (1:5): 432 Hartlepool 2D (1:5): 433
Hartlepool 1A (1:5): 434 Hartlepool 4B (1:5): 435 Hartlepool 4C
(1:5): 436 Hartlepool 4A (1:5): 437 Hartlepool 3A (1:5): 438 Hart-
lepool 3B (1:5): 439 Hartlepool 3C (1:5).

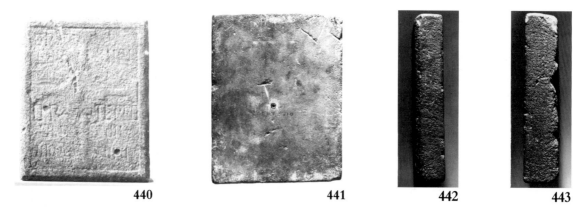

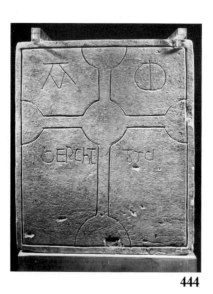

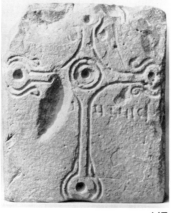

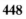

Plate 85 **440** Hartlepool 5A (1:5): **441** Hartlepool 5C (1:5): **442** Hartlepool 5B (1:5): **443** Hartlepool 7C (1:5): **444** Hartlepool 6A (1:5): **445** Hartlepool 7B (1:5): **446** Hartlepool 7A (1:5): **447** Hartlepool 8A (1:5): **448** Hartlepool 8C (1:5): **449** Hartlepool 8B (1:5).

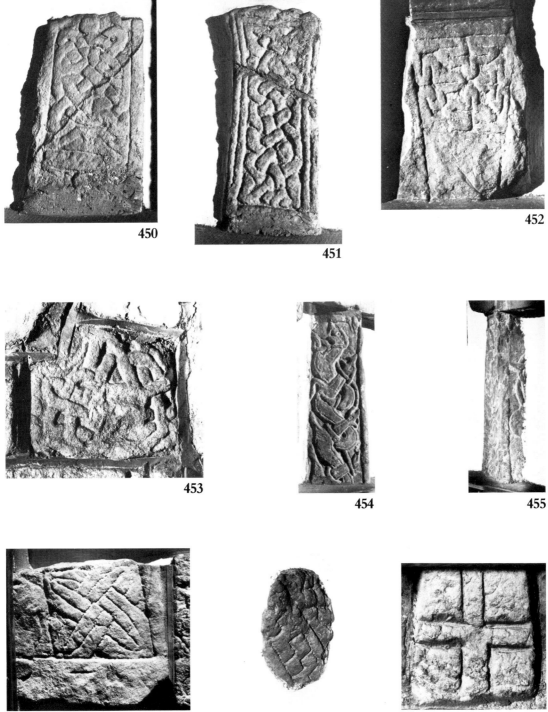

Plate 86 **450** Haughton–le–Skerne 1A: **451** Haughton–le–Skerne
2?A: **452** Haughton–le–Skerne 4A: **453** Haughton–le–Skerne 7A: **454**
Haughton–le–Skerne 6A: **455** Haughton–le–Skerne 6B: **456**
Haughton–le–Skerne 5A: **457** Haughton–le–Skerne 9: **458**
Haughton–le–Skerne 12A.

Plate 87 **459** Haughton-le-Skerne 3A: **460** Haughton-le-Skerne
3A/B: **461** Haughton-le-Skerne 3D/A.

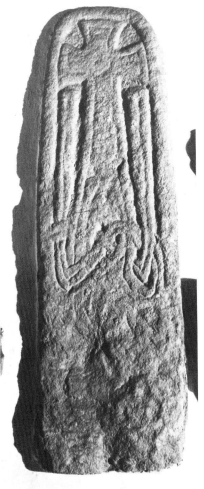

463

464

462

465

466

Plate 88 **462** Haughton-le-Skerne 10A: **463** Haughton-le-Skerne
11A: **464** Haughton-le-Skerne 13A (nts): **465** Haughton-le-Skerne
14 (1:5): **466** Haughton-le-Skerne 8A.

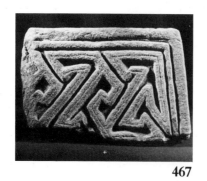

467

468

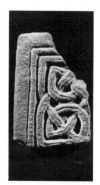

469

470

471

472

473

Plate 89 **467** Hurworth 1?A: **468** Hurworth 1?D: **469** Hurworth
1?B: **470** Hurworth 1?C: **471** Hurworth 2?C (nts): **472** Hurworth
2?B (nts): **473** Hurworth 2?E (nts).

474 475 476 477

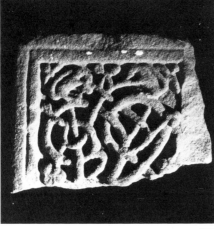

478 479

480 481

Plate 90 **474** Jarrow 1A: **475** Jarrow 1B: **476** Jarrow 1C: **477** Jarrow 1D: **478** Jarrow 2A (1:5): **479** Jarrow 2B (1:5): **480** Jarrow 2C (1:5): **481** Jarrow 2D (1:5).

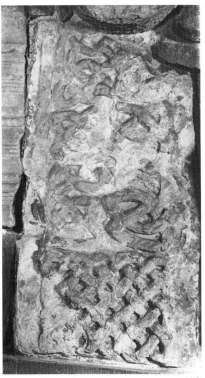

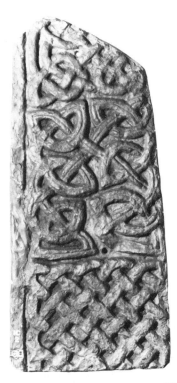

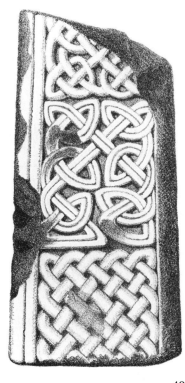

482

483

484

485

486

Plate 91 **482** Jarrow 3A: **483** Jarrow 3A (cast): **484** Jarrow 3B (after Stuart 1867): **485** Jarrow 3A (after Stuart 1867): **486** Jarrow 3D (cast, 1:5).

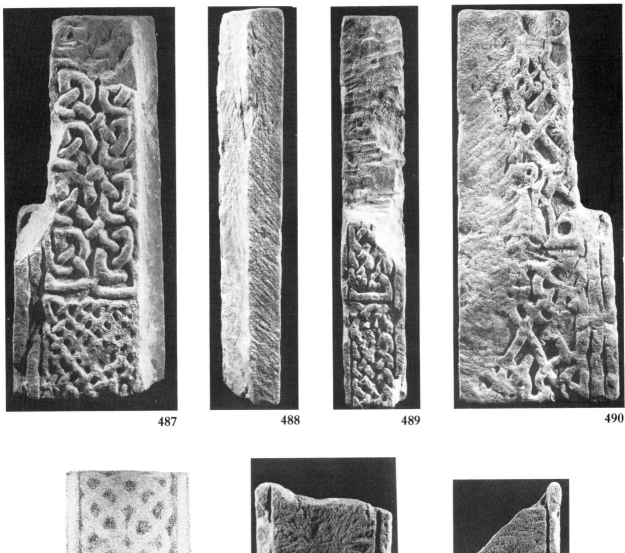

487 488 489 490

491 492 493

494 495

Plate 92 **487** Jarrow 4A: **488** Jarrow 4B: **489** Jarrow 4D: **490** Jarrow
4C: **491** Jarrow 5 (after Stuart 1867): **492** Jarrow 7A (1:5): **493** Jarrow
7D (1:5): **494** Jarrow 7B (1:5): **495** Jarrow 7C (1:5).

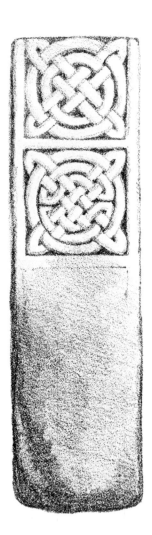

497

499

498

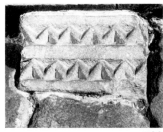

500

496

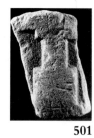

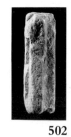

501

502

503

504

Plate 93 **496** Jarrow 6A (after Stuart 1867): **497** Jarrow 9A (1:5):
498 Jarrow 9D/F (1:5): **499** Jarrow 8A (1:5): **500** Jarrow 15 (1:5): **501**
Jarrow 11A (1:5): **502** Jarrow 11B (1:5): **503** Jarrow 11C (1:5): **504**
Jarrow 11D (1:5).

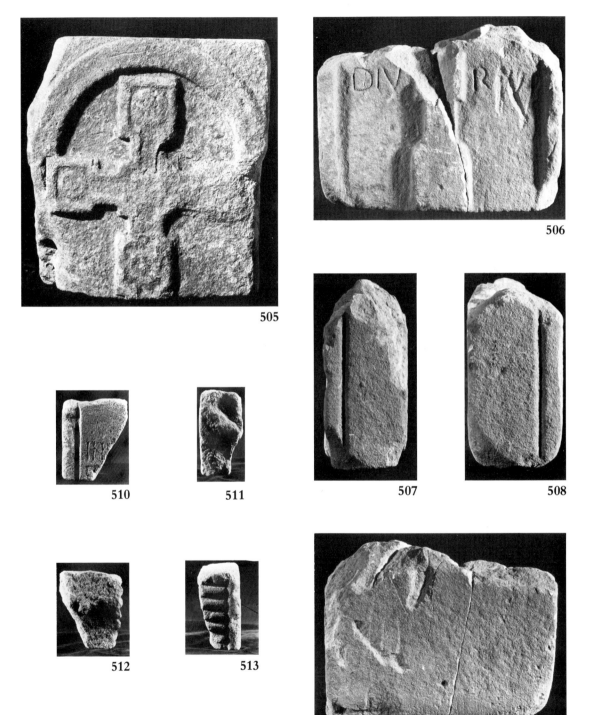

Plate 94 **505** Jarrow 10A: **506** Jarrow 12A (1:5): **507** Jarrow 12B
(1:5): **508** Jarrow 12D (1:5): **509** Jarrow 12C (1:5): **510** Jarrow 13A
(1:5): **511** Jarrow 13B (1:5): **512** Jarrow 13C (1:5): **513** Jarrow 13D
(1:5).

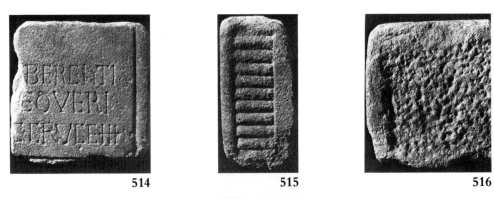

514 515 516

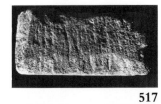

517

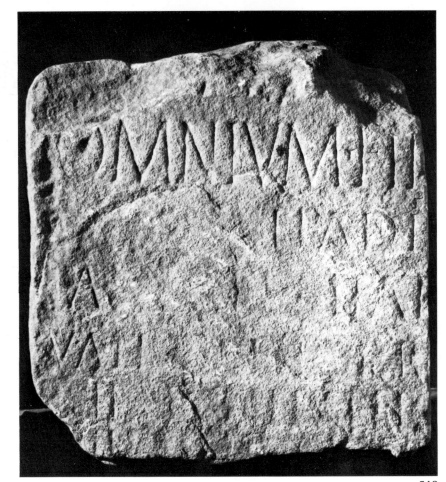

518

Plate 95 **514** Jarrow 14A (1:5): **515** Jarrow 14B (1:5): **516** Jarrow
14C (1:5): **517** Jarrow 14E (1:5): **518** Jarrow 16bE (1:5).

519

520

Plate 96 **519** Jarrow 16bA (1:5): **520** Jarrow 16aA (1:5).

521

522 523

Plate 97 **521** Jarrow 16bF (1:5): **522** Jarrow 18 (1:5): **523** Jarrow
21a–b (1:2).

524

525

526

Plate 98 524 Jarrow 17 (cast, 1:5): 525 Jarrow 20: 526 Jarrow 19.

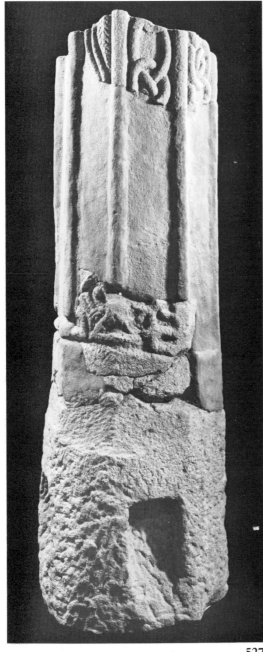

527

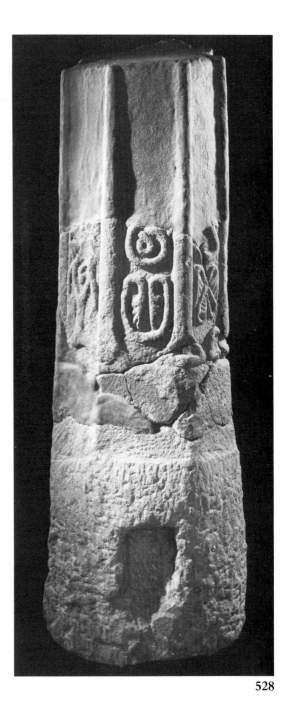

528

Plate 99 **527** Jarrow 22D/E/F: **528** Jarrow 22H/A/B.

529

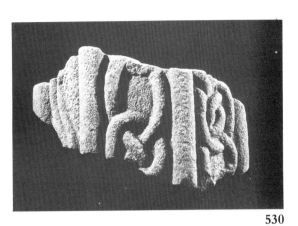

530

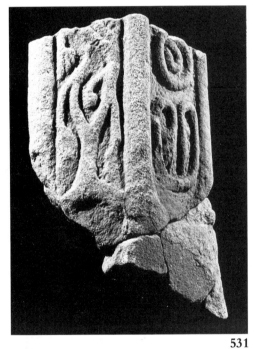

531

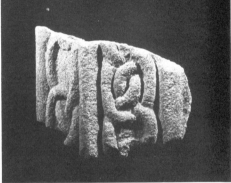

532

533

534

Plate 100 **529** Jarrow 22D/E upper (1:5): **530** Jarrow 22D/E/F upper (1:5): **531** Jarrow 22H/A lower (1:5): **532** Jarrow 22E/F upper (1:5): **533** Jarrow 22D/E/F lower (1:5): **534** Jarrow 22H/A/B lower (1:5).

535

536

537

538

540

539

541

542

Plate 101 **535** Jarrow 22A/B lower (1:5): **536** Jarrow 23 A/D/F (1:5):
537 Jarrow 26A: **538** Jarrow 29B (1:5): **539** Jarrow 29A (1:5): **540**
Jarrow 25aA: **541** Jarrow 29C (1:5): **542** Jarrow 27A.

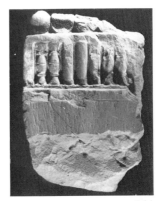

544

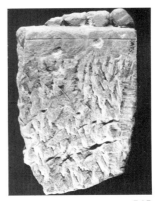

545

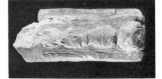

546

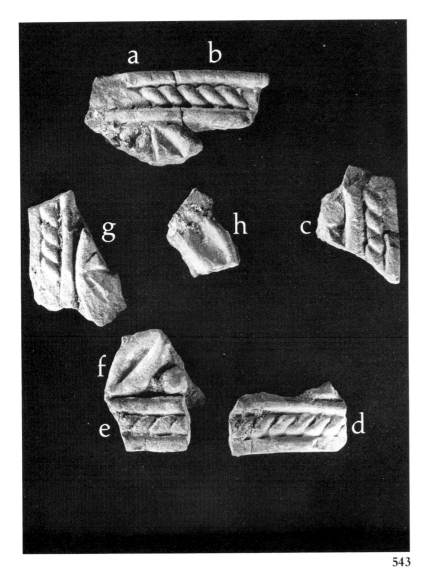

543

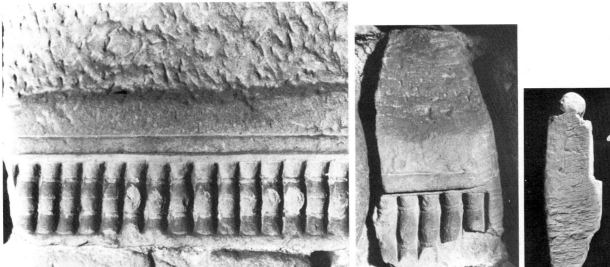

547

548

549

Plate 102 **543** Jarrow 24a–h (1:2): **544** Jarrow 28A: **545** Jarrow 28C: **546** Jarrow 28E: **547** Jarrow 25bA: **548** Jarrow 25cA: **549** Jarrow 28D.

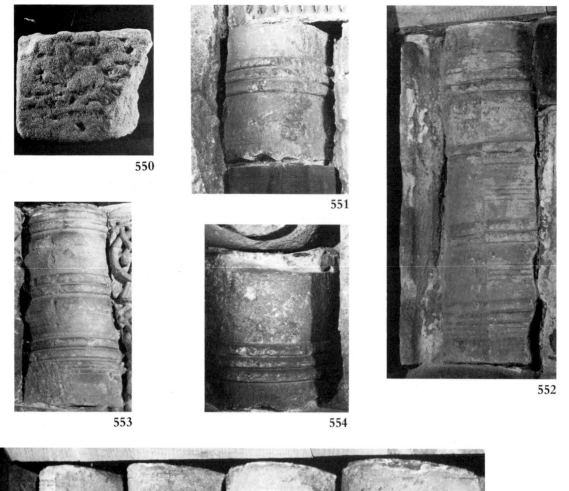

550

551

552

553

554

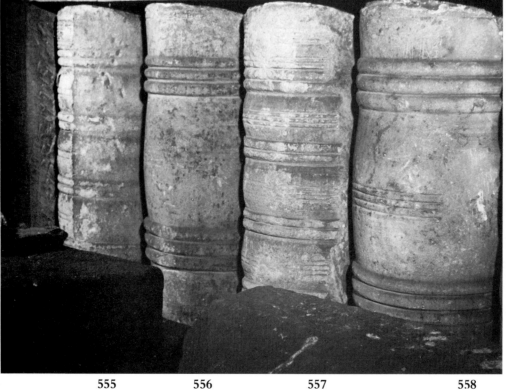

555 556 557 558

Plate 103 **550** Jarrow 29F (1:5): **551** Jarrow 30a: **552** Jarrow 30b:
553 Jarrow 30c: **554** Jarrow 30d: **555** Jarrow 30e: **556** Jarrow 30f: **557**
Jarrow 30g: **558** Jarrow 30h.

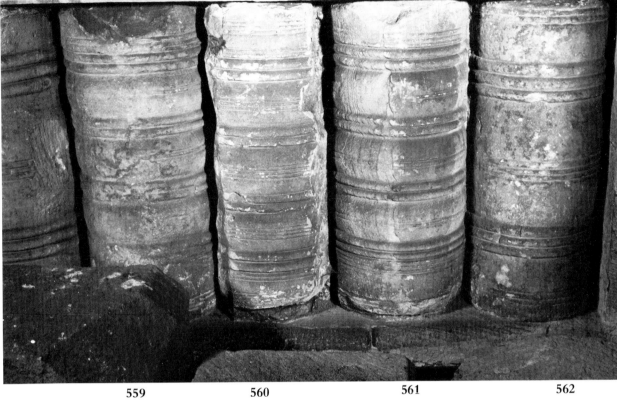

559 560 561 562

563 564 565

Plate 104 **559** Jarrow 30i: **560** Jarrow 30j: **561** Jarrow 30k: **562**
Jarrow 30l: **563** Jarrow 30m: **564** Jarrow 30n: **565** Jarrow 30o.

566 567

568 569 570

Plate 105 **566** Jarrow 30p: **567** Jarrow 30q: **568** Jarrow 30r: **569** Jarrow 30s: **570** Jarrow 30t.

571

572

573

574

575

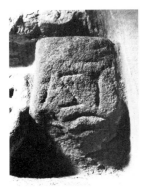

576

577

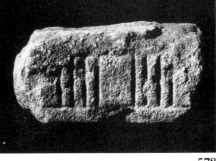

578

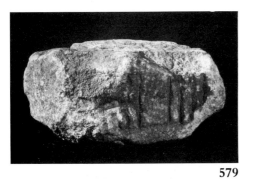

579

580

Plate 106 **571** Jarrow 30u: **572** Jarrow 30v: **573** Jarrow 30x: **574** Jarrow 30y: **575** Jarrow 30w: **576** Jarrow 31A (1:5): **577** Jarrow 31A/E (1:5): **578** Jarrow 32A (1:5): **579** Jarrow 32B/C (1:5): **580** Jarrow 32C/D (1:5).

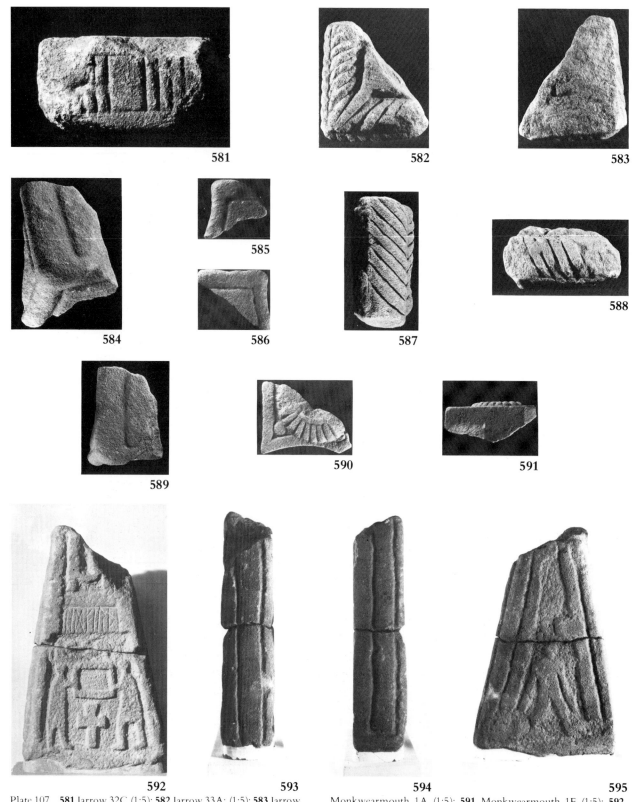

Plate 107 **581** Jarrow 32C (1:5): **582** Jarrow 33A: (1:5): **583** Jarrow 33C (1:5): **584** Monkwearmouth 2A/B/E (1:5): **585** Monkwearmouth 2B (1:5): **586** Monkwearmouth 2A (1:5): **587** Jarrow 33D (1:5): **588** Jarrow 33F (1:5): **589** Monkwearmouth 2E (1:5): **590** Monkwearmouth 1A (1:5): **591** Monkwearmouth 1F (1:5): **592** Monkwearmouth 3A (1:5): **593** Monkwearmouth 3B (1:5): **594** Monkwearmouth 3D (1:5): **595** Monkwearmouth 3C (1:5)

596

597

Plate 108 **596** Legs Cross, Bolam 1A (nts): **597** Legs Cross, Bolam 1B (nts).

598

599

Plate 109 **598** Legs Cross, Bolam 1C (nts): **599** Legs Cross, Bolam 1D (nts).

600

601

602

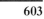

603

604

Plate 110 **600** Monkwearmouth 4A (1:2): **601** Monkwearmouth
10A (1:5): **602** Monkwearmouth 10B (1:5): **603** Monkwearmouth
10C (1:5): **604** Monkwearmouth 5A (1:5).

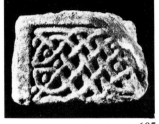

605

606

607

608

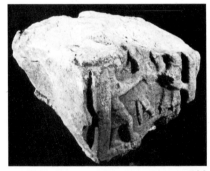

609

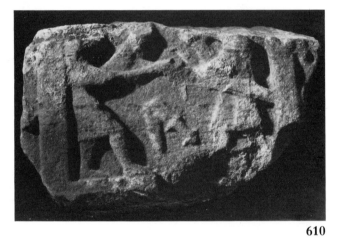

610

611

Plate 111 **605** Monkwearmouth 6A: **606** Monkwearmouth 6C:
607 Monkwearmouth 6D: **608** Monkwearmouth 6E: **609** Monk-
wearmouth 7A/D: **610** Monkwearmouth 7A (nts): **611** Monk-
wearmouth 7D.

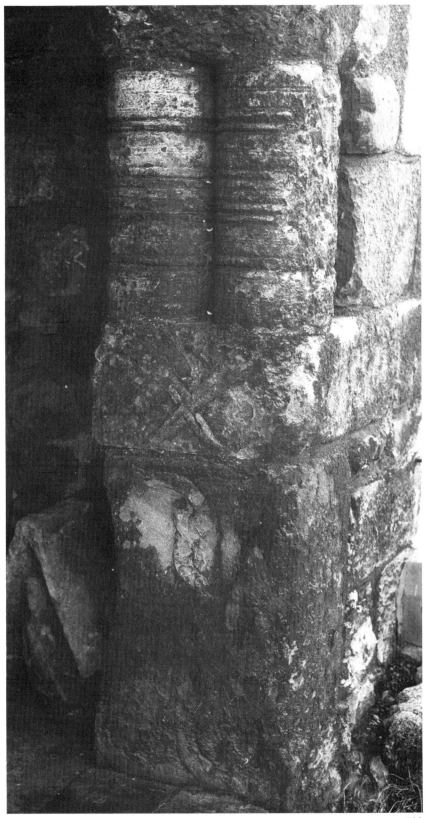

612

Plate 112 **612** Monkwearmouth 8a.

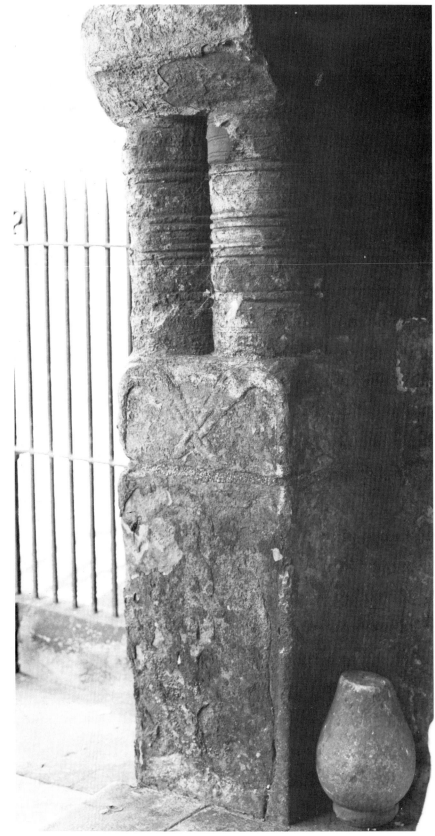

Plate 113 **613** Monkwearmouth 8b. **613**

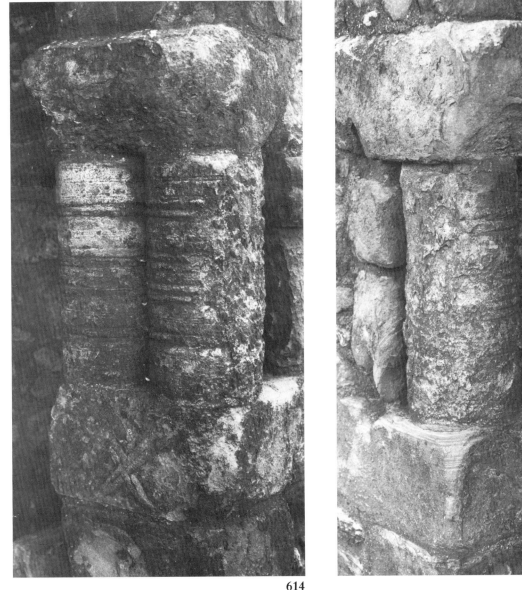

614

615

Plate 114 **614** Monkwearmouth 8a: **615** Monkwearmouth 8b.

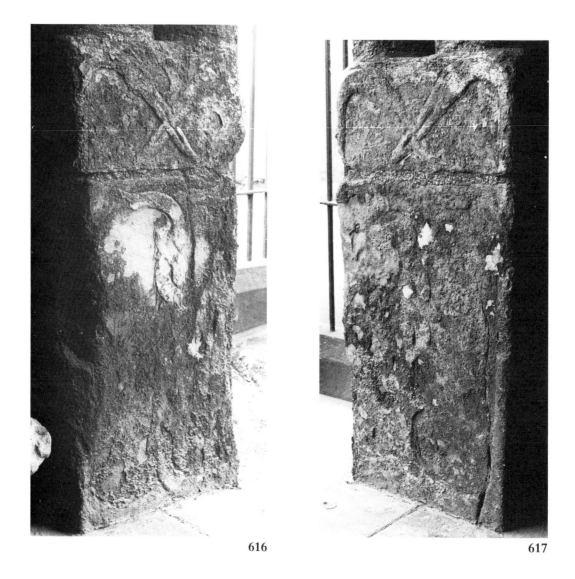

616

617

Plate 115 **616** Monkwearmouth 8a: **617** Monkwearmouth 8b.

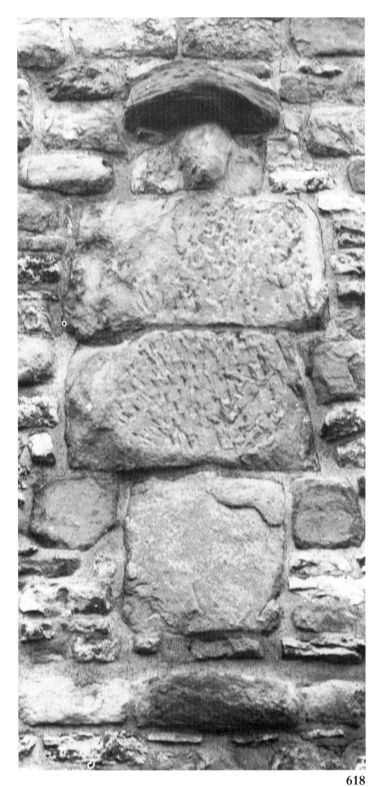

619

620

618

Plate 116 **618** Monkwearmouth 11 (nts): **619** Monkwearmouth
28A: **620** Monkwearmouth 29A.

Plate 117　**621** Monkwearmouth 12bA (nts): **622** Monkwearmouth
12cA: **623** Monkwearmouth 12cD: **624** Monkwearmouth 12aA
(after (—)1862–8c. nts): **625** Monkwearmouth 12aA (after
(—)1862 8c. nts).

626

627 628

Plate 118 626 Monkwearmouth 13: 627 Monkwearmouth 14a:
628 Monkwearmouth 14b.

629

630

631

632

Plate 119 **629** Monkwearmouth 14c (nts): **630** Monkwearmouth 14d (nts): **631** Monkwearmouth 14e (nts): **632** Monkwearmouth 14f (nts).

633　　　　634

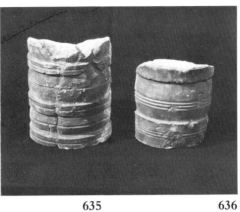

635　　　　636

637　　　　638

639　　　　640

641　　　　642

643　　　　644

645　　　　**646**

647　　　　**648**

Plate 120　**633** Monkwearmouth 14g: **634** Monkwearmouth 14h: **635** Monkwearmouth 14i: **636** Monkwearmouth 14j: **637** Monkwearmouth 14k: **638** Monkwearmouth 14l: **639** Monkwearmouth 14m: **640** Monkwearmouth 14n: **641** Monkwearmouth 14o: **642** Monkwearmouth 14p: **643** Monkwearmouth 14q: **644** Monkwearmouth 14r: **645** Monkwearmouth 14s: **646** Monkwearmouth 14t: **647** Monkwearmouth 14u: **648** Monkwearmouth 14v.

649 650 651 652

653

654 655

657 658

659 660

656 661 662

Plate 121 **649** Monkwearmouth 14w: **650** Monkwearmouth 14x: **651** Monkwearmouth 14y: **652** Monkwearmouth 14z: **653** Monk-wearmouth 14ac: **654** Monkwearmouth 14aa (1:5): **655** Monk-wearmouth 14ab (1:5): **656** Monkwearmouth 9A (1:5): **657** Monk-wearmouth 14ad: **658** Monkwearmouth 14ae (1:5): **659** Monk-wearmouth 14ah (1:5): **660** Monkwearmouth 14ag (1:5): **661** Monkwearmouth 14af (1:5): **662** Monkwearmouth 14ai (1:5).

663

664

665

667

666

Plate 122 **663** Monkwearmouth 15aA: **664** Monkwearmouth 15aB: **665** Monkwearmouth 15aC: **666** Monkwearmouth 15aD: **667** Monkwearmouth 15aA/B.

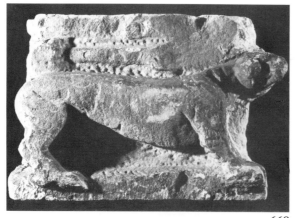

668

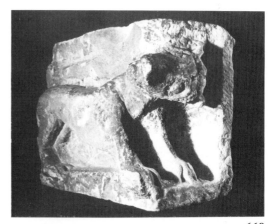

669

670

671

672

Plate 123 **668** Monkwearmouth 15bA: **669** Monkwearmouth
15bA/B: **670** Monkwearmouth 15bD: **671** Monkwearmouth 15bB:
672 Monkwearmouth 15bC.

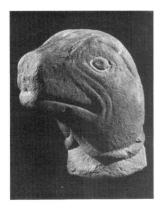

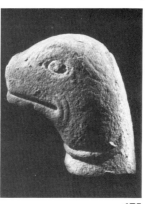

673

674

675

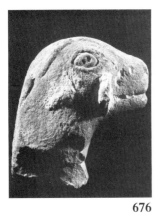

677

678

679

676

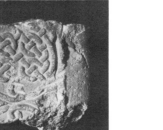

682

680

681

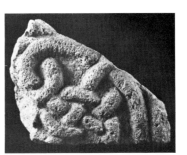

683

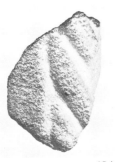

684 685 686 687

Plate 124 **673** Monkwearmouth 16A/D: **674** Monkwearmouth 16B: **675** Monkwearmouth 16A: **676** Monkwearmouth 16C: **677** Monkwearmouth 21A (1:5): **678** Monkwearmouth 21D (1:5): **679** Monkwearmouth 21C (1:5): **680** Monkwearmouth 22A (1:5): **681** Monkwearmouth 17 (1:5): **682** Monkwearmouth 18 (1:2): **683** Monkwearmouth 19A (1:2): **684** Monkwearmouth 23 (1:2): **685** Monkwearmouth 25A (1:5): **686** Monkwearmouth 20B (1:5): **687** Monkwearmouth 20C/D (1:5).

688

689

690

691

692

693

694

695

696

697

Plate 125 **688** Monkwearmouth 24A/E (1:2): **689** Monkwear-
mouth 24A/B/E (1:2): **690** Monkwearmouth 24A/D/E (1:2): **691**
Monkwearmouth 26A (1:2): **692** Monkwearmouth 26E (1:2): **693**
Monkwearmouth 27A (1.2): **694** Norton 1A: **695** Norton 2A: **696**
Norton 2D/A: **697** Seaham 1a (exterior).

698

Plate 126 **698** Seaham 1b (exterior): **699** Seaham 1a (interior).

699

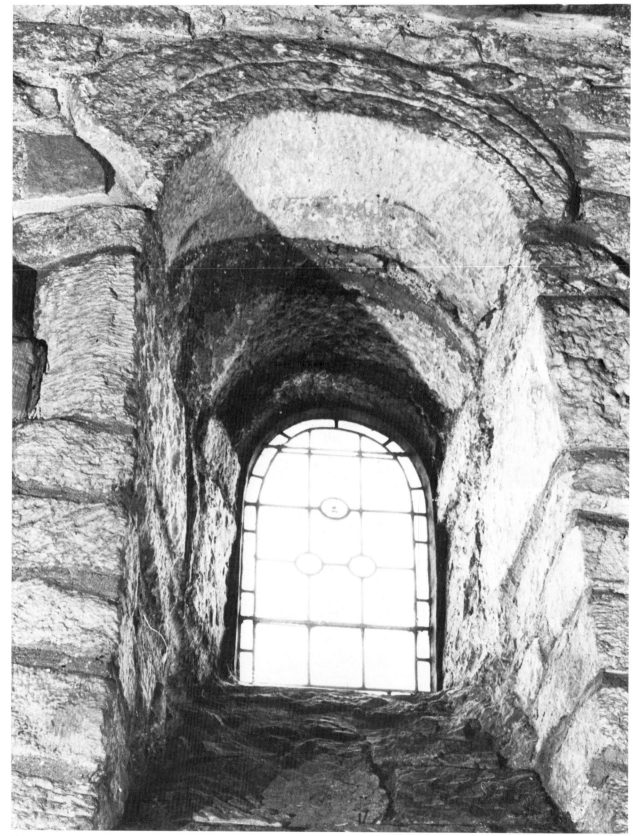

Plate 127 **700** Seaham 1b (interior).

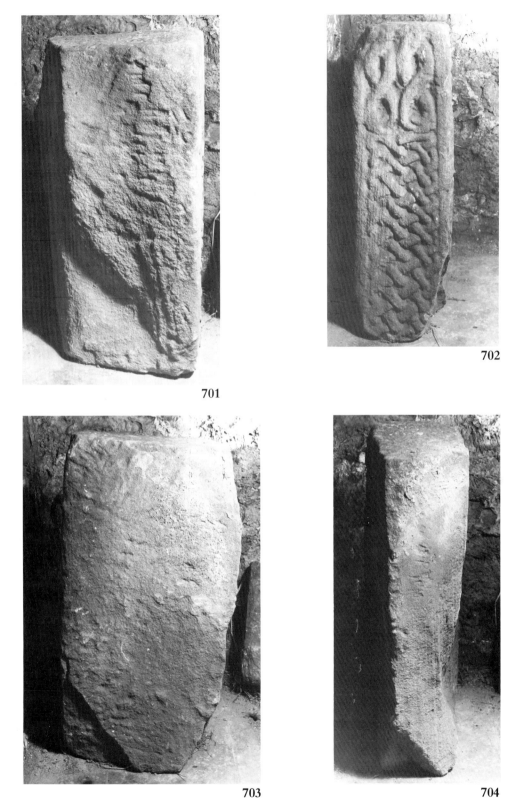

701

702

703

704

Plate 128 **701** Sockburn 1A: **702** Sockburn 1B: **703** Sockburn 1C:
704 Sockburn 1D.

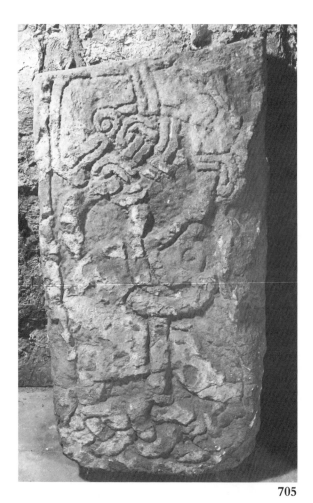

705

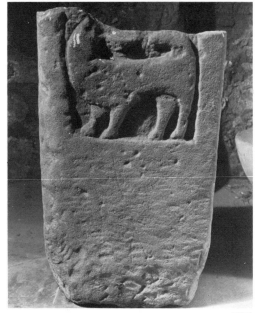

706

707

708

709

Plate 129　**705** Sockburn 2A: **706** Sockburn 4A: **707** Sockburn 4B:
708 Sockburn 4C: **709** Sockburn 4D.

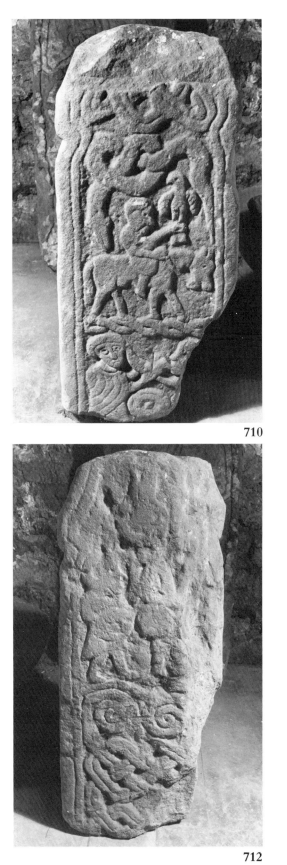

710

711

712

713

Plate 130 **710** Sockburn 3A: **711** Sockburn 3B: **712** Sockburn 3C:
713 Sockburn 3D.

714

715

716

717

Plate 131 **714** Sockburn 5A: **715** Sockburn 5B: **716** Sockburn 5C:
717 Sockburn 5D.

718

719

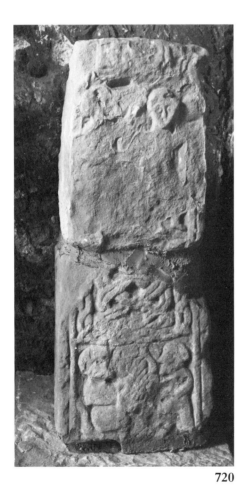

720

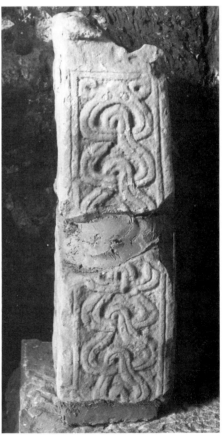

721

Plate 132 **718** Sockburn 11A: **719** Sockburn 11B: **720** Sockburn
6A: **721** Sockburn 6B.

722

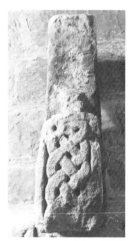

723

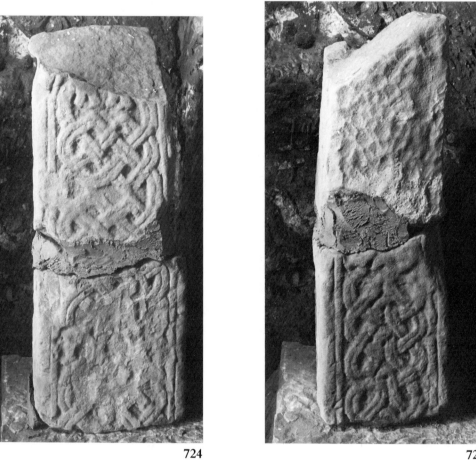

724

725

Plate 133　**722** Sockburn 11C: **723** Sockburn 11D: **724** Sockburn
6C: **725** Sockburn 6D.

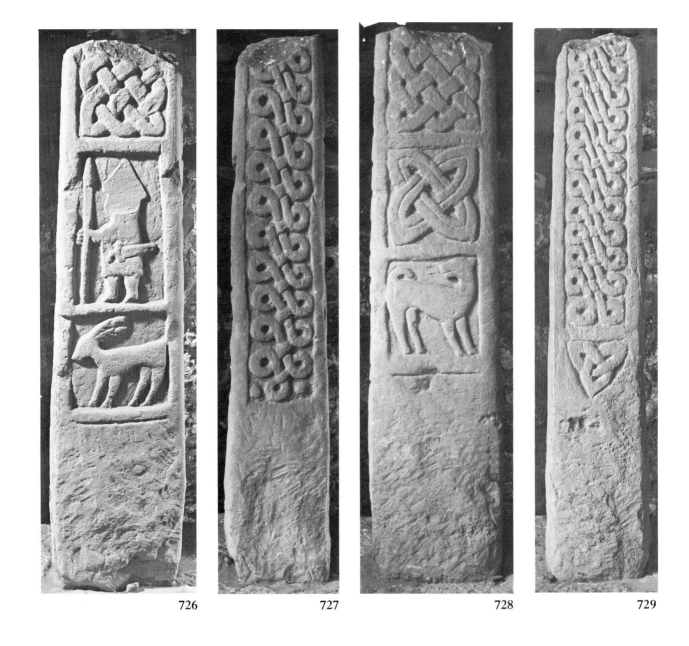

726 727 728 729

Plate 134 **726** Sockburn 7A: **727** Sockburn 7B. **728** Sockburn 7C:
729 Sockburn 7D.

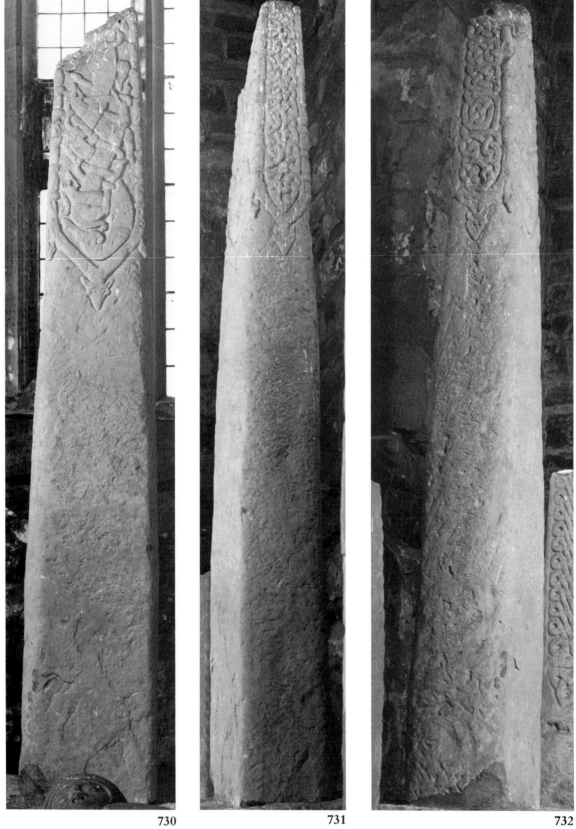

730

731

732

Plate 135 **730** Sockburn 8A (nts): **731** Sockburn 8B (nts): **732** Sockburn 8D (nts).

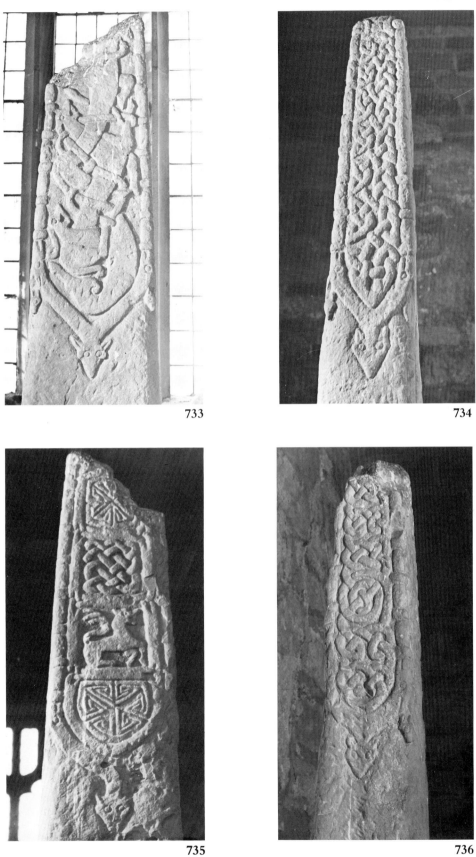

733

734

735

736

Plate 136 **733** Sockburn 8 A: **734** Sockburn 8 B: **735** Sockburn 8 C:
736 Sockburn 8 D.

737

738

739

740

Plate 137 **737** Sockburn 9A: **738** Sockburn 9B: **739** Sockburn 9C:
740 Sockburn 9D.

741

742

743

744

Plate 138 **741** Sockburn 15A: **742** Sockburn 15C: **743** Sockburn
10A: **744** Sockburn 10B.

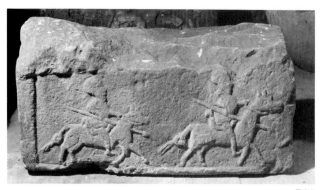

745

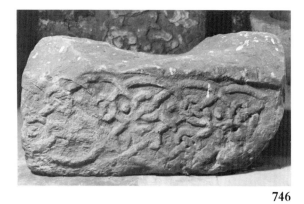

746

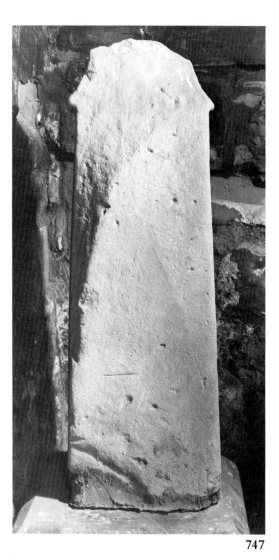

747

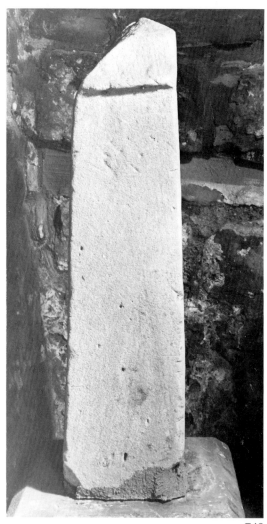

748

Plate 139 **745** Sockburn 14A: **746** Sockburn 14C: **747** Sockburn
10C: **748** Sockburn 10D.

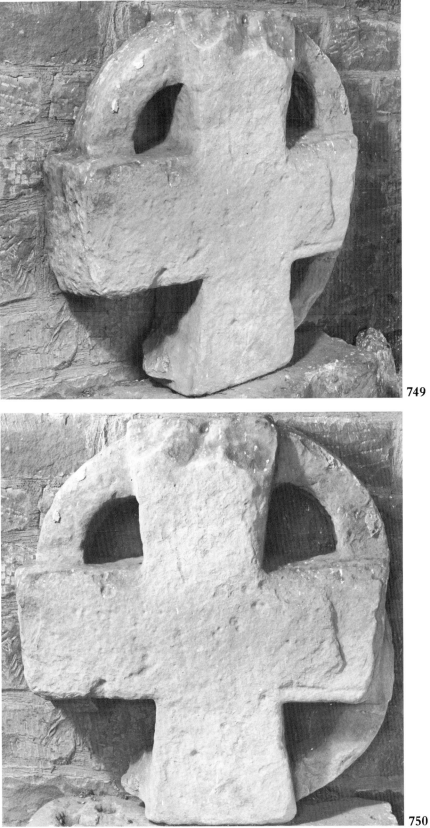

749

750

Plate 140 **749** Sockburn 12D/A: **750** Sockburn 12A.

751

752

753

754

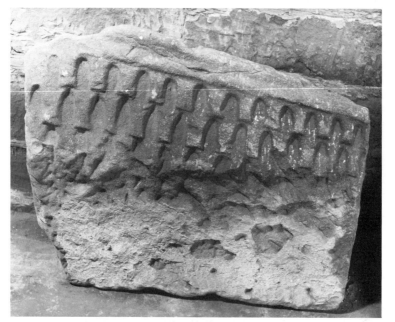

755

756

757

758

Plate 141 **751** Sockburn 13A (1:5): **752** Sockburn 13C (1:5): **753**
Sockburn 13E (1:5): **754** Sockburn 13F (1:5): **755** Sockburn 19A: **756**
Sockburn 22 (1:5): **757** Sockburn 19C: **758** Sockburn 23.

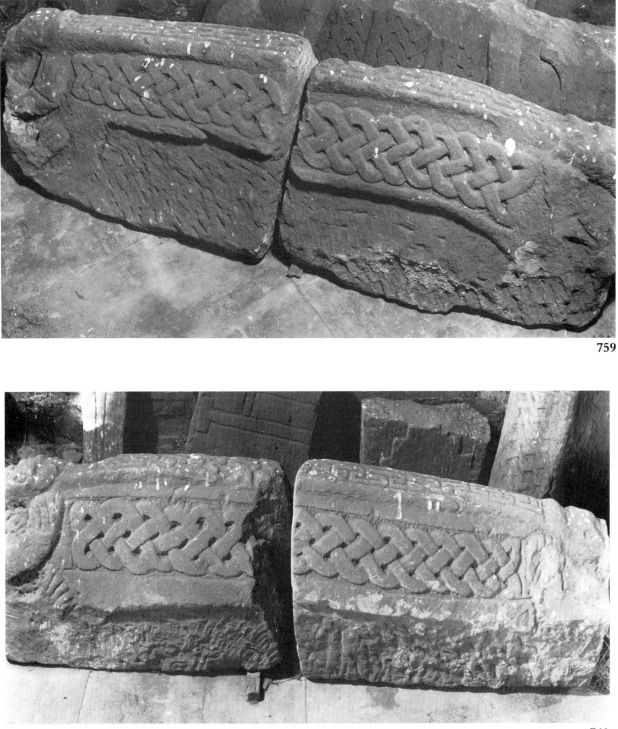

759

760

Plate 142 **759** Sockburn 16A (nts): **760** Sockburn 16C (nts).

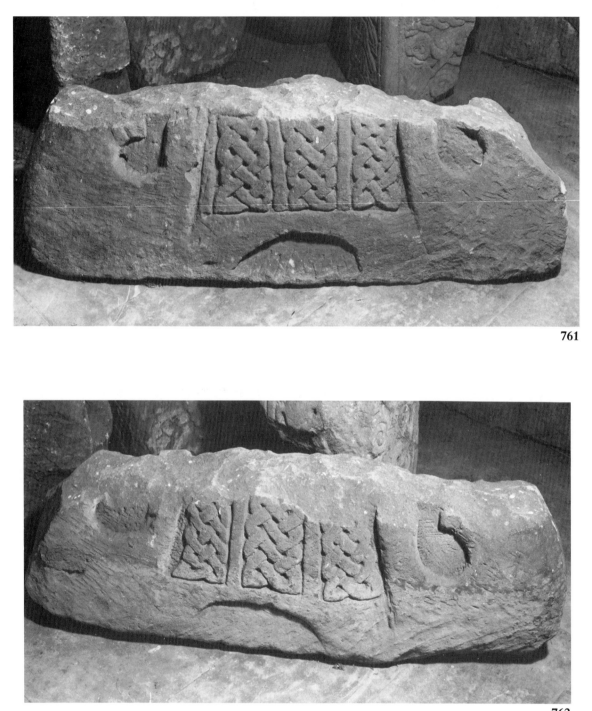

761

762

Plate 143 **761** Sockburn 17A: **762** Sockburn 17C.

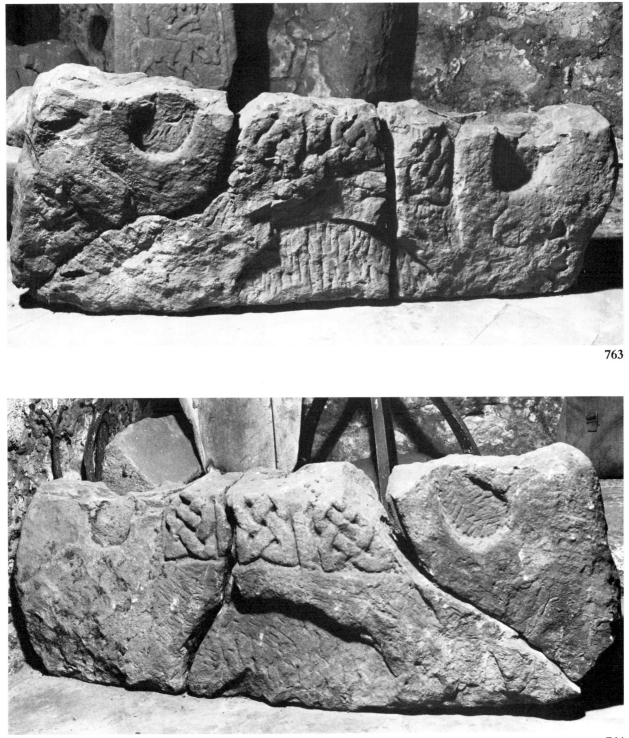

763

764

Plate 144 **763** Sockburn 18A: **764** Sockburn 18C.

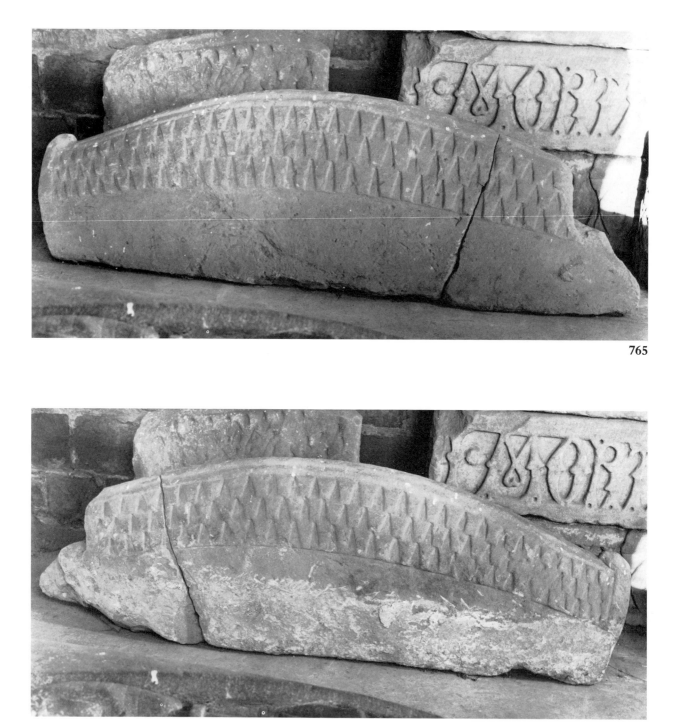

765

766

Plate 145 **765** Sockburn 20A (nts): **766** Sockburn 20C (nts).

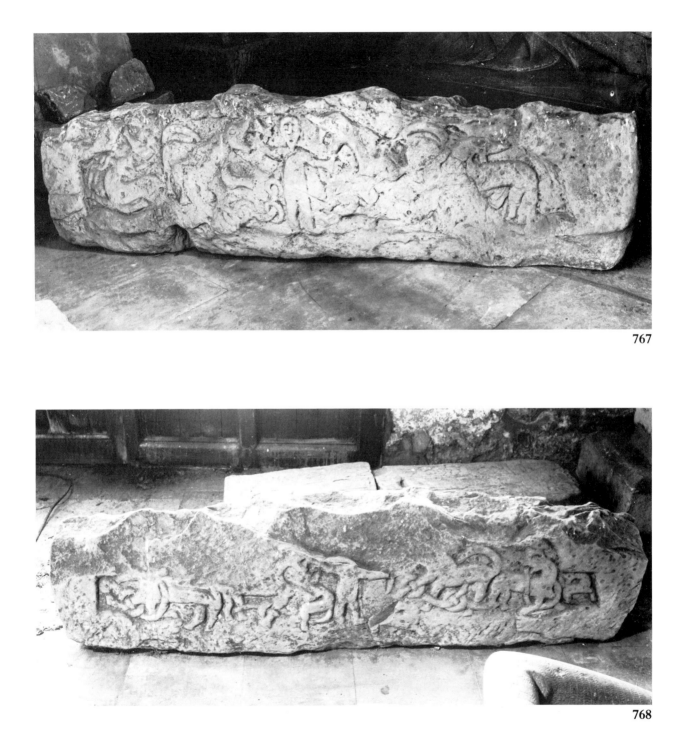

767

768

Plate 146 **767** Sockburn 21A (nts): **768** Sockburn 21C (nts).

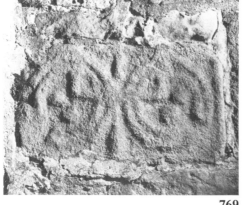

769

770

771

772

773

774

775

Plate 147 **769** Staindrop 1A: **770** Winston 1E: **771** Winston 1F: **772**
Winston 1A: **773** Winston 1B: **774** Winston 1C: **775** Winston 1D.

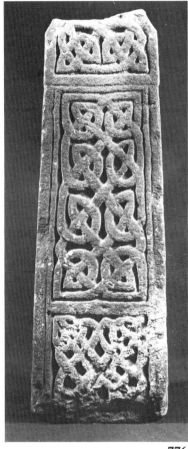

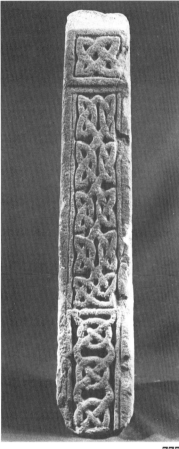

776

777

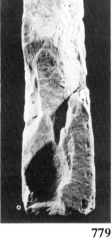

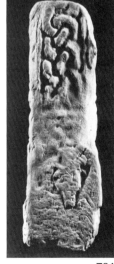

778

779

780

781

Plate 148 **776** Unknown Provenance 1A: **777** Unknown Provenance 1B: **778** Unknown Provenance 2A: **779** Unknown Provenance 2B: **780** Unknown Provenance 2C: **781** Unknown Provenance 2D.

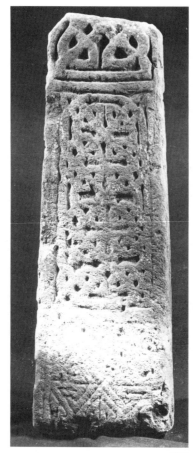

782

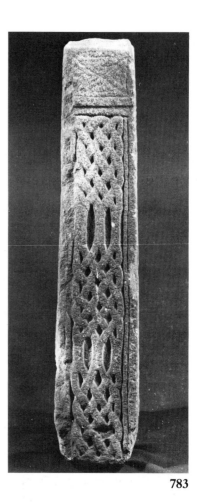

783

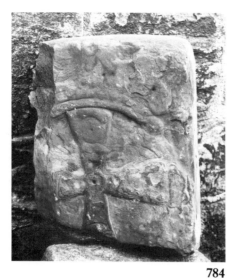

784

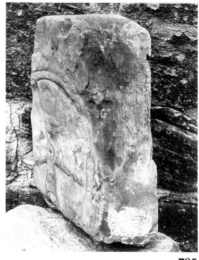

785

Plate 149　782 Unknown Provenance 1C: 783 Unknown Provenance 1D: 784 Darlington 5A (nts): 785 Darlington 5A/B (nts).

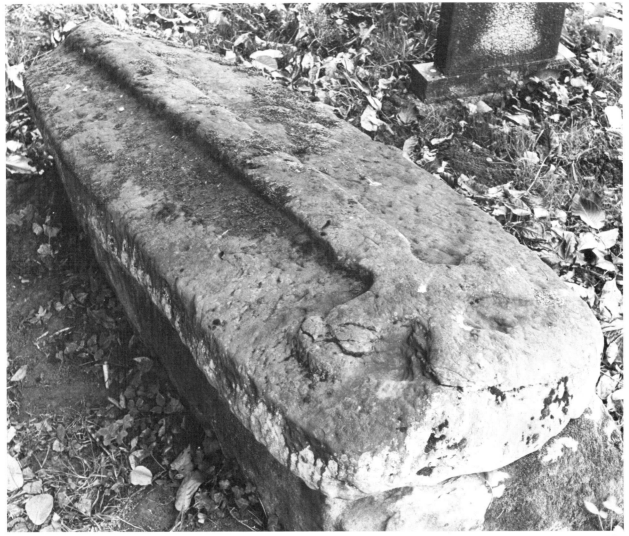

786

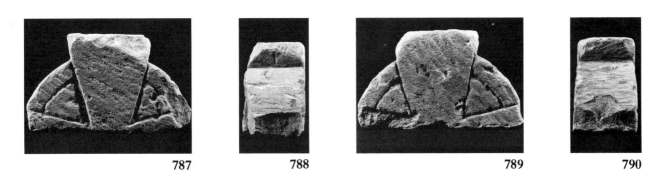

787 788 789 790

Plate 150 **786** Dinsdale 11A/B/C: **787** Durham 15A: **788** Durham
15B: **789** Durham 15C: **790** Dinsdale 15D.

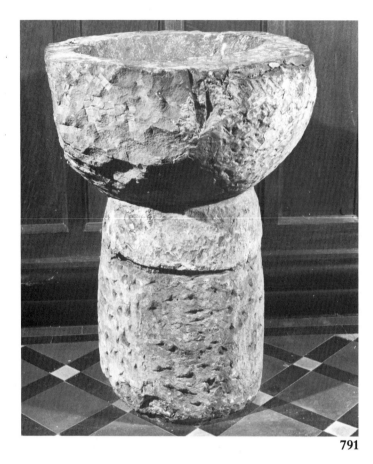

791

792

793

794

795

Plate 151 **791** Dinsdale 12: **792** Egglescliffe 3A: **793** Sockburn
24 (1:5): **794** Gainford 32A: **795** Dalton–le–Dale 2 (nts).

796

797

Plate 152 **796** Gainford 33A: **797** Monkwearmouth 30A.

798

799

Plate 153 **798** Sockburn 25A/B: **799** Sockburn 25B/F.

800

801

Plate 154 **800** Hartlepool 9D/A (after Ventress 1901–2, nts): **801** Sockburn 25D.

802

803

804

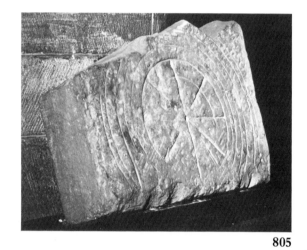

805

806

807

Plate 155　**802** Hart 12 (nts): **803** Pittington 1 (nts): **804** Darlington 6A: **805** Darlington 6B/C: **806** Darlington 6C: **807** Middleton One Row 1 (nts).

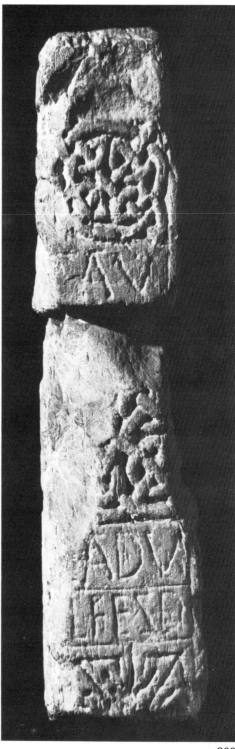

808

809

Plate 156 **808** Alnmouth 1A (1:5): **809** Alnmouth 1B (1:5).

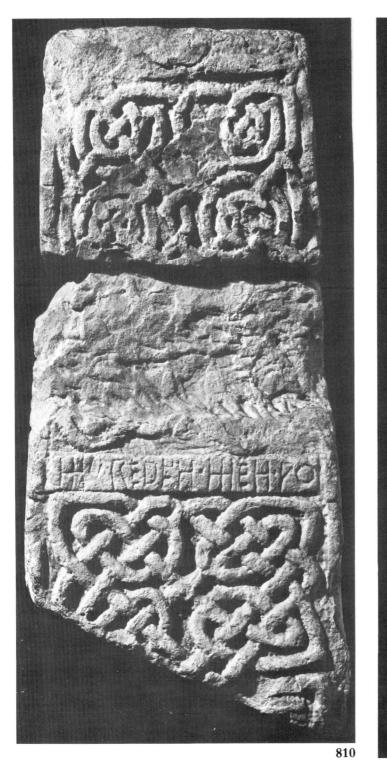

810

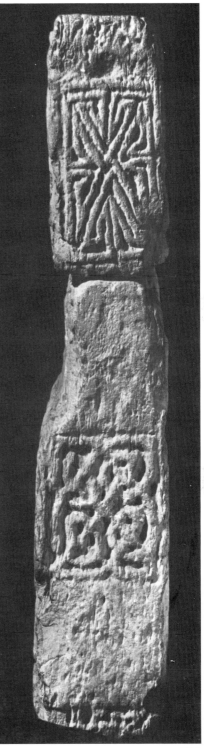

811

Plate 157 **810** Alnmouth 1C (1:5): **811** Alnmouth 1D (1:5).

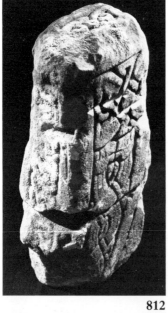

812

813

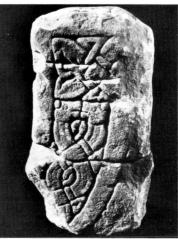

814

815

816

817

818

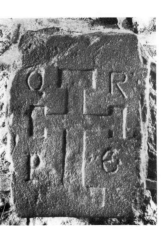

819

Plate 158 **812** Bamburgh 1D/A/E: **813** Bamburgh 1D: **814** Bamburgh 1A: **815** Bamburgh 1C: **816** Bamburgh 1E: **817** Bamburgh 1B: **818** Birtley 1: **819** Birtley 2A (1:5).

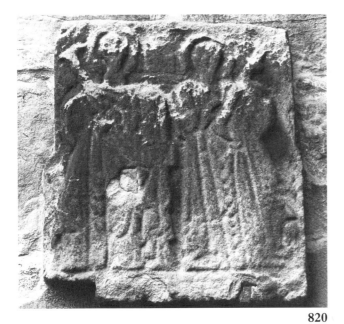

821

820

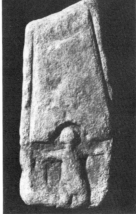

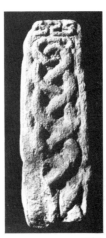

822

823

824

825

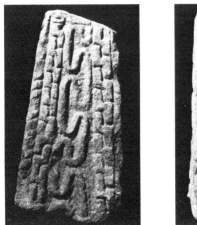

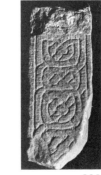

826

827

828

829

Plate 159 **820** Bedlington 1: **821** Bothal 1A: **822** Bothal 1B: **823**
Bothal 1C: **824** Bothal 2A: **825** Bothal 2B: **826** Bothal 2C: **827**
Bothal 2D: **828** Bothal 3A: **829** Bothal 3B.

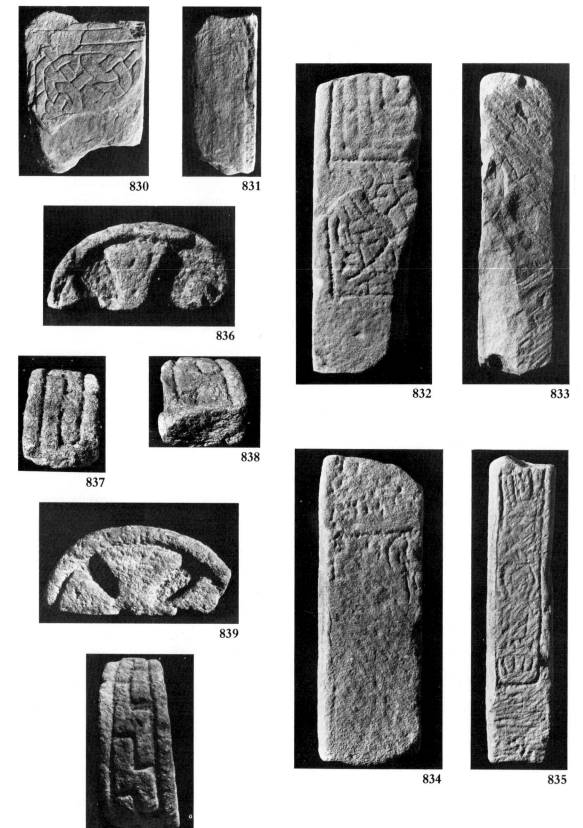

830

831

832

833

836

837

838

839

834

835

840

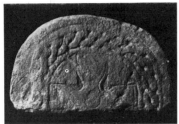
841

842

843

844

846

845

847

849

850

851

852

848

Plate 161 **841** Bothal 6A: **842** Bothal 6D/E: **843** Bothal 6E: **844**
Bothal 6C: **845** Bothal 6B/E: **846** Bothal 7: **847** Bywell 2B: **848**
Bywell 2A: **849** Carham 3A: **850** Carham 3B: **851** Carham 3F: **852**
Carham 3C/D.

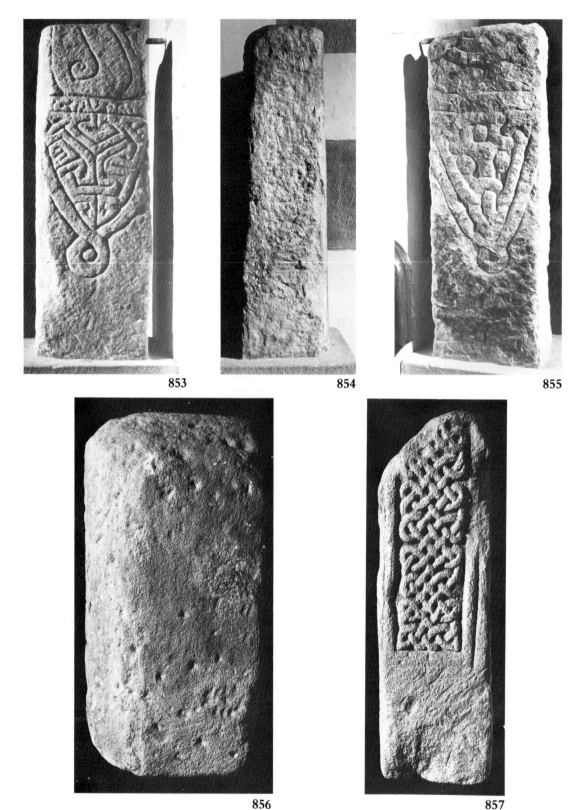

853 854 855

856 857

Plate 162 **853** Bywell 1A: **854** Bywell 1D: **855** Bywell 1C: **856** Carham 1D/A: **857** Carham 1B.

858

859

860 861 862 863

Plate 163 **858** Carham 1C: **859** Carham 2F (nts): **860** Carham 2A:
861 Carham 2B: **862** Carham 2C: **863** Carham 2D.

864

865

866

867

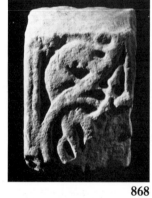

868

869

870

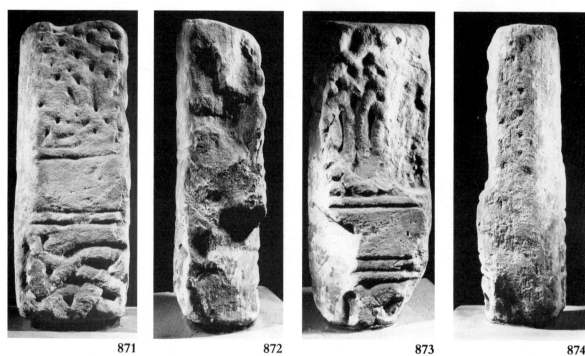

871

872

873

874

Plate 164 864 Coquet Island 1A (1:5): 865 Coquet Island 1D/A (1:5): 866 Coquet Island 1C (1:5): 867 Edlingham 1C: 868 Edlingham 1A: 869 Edlingham 1B: 870 Edlingham 1D: 871 Great Farne Island 1A: 872 Great Farne Island 1B: 873 Great Farne Island 1C: 874 Great Farne Island 1D.

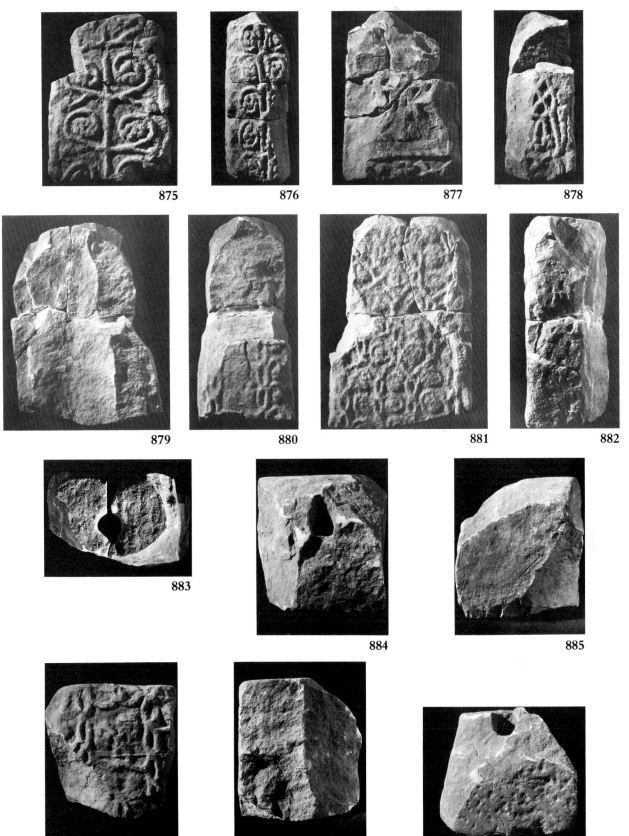

875 876 877 878

879 880 881 882

883

884 885

886 887 888

Plate 165 **875** Falstone 1aA: **876** Falstone 1aB: **877** Falstone 1aC: **878** Falstone 1aD: **879** Falstone 1bA: **880** Falstone 1bB: **881** Falstone 1bC: **882** Falstone 1bD· **88**.³ Falstone 1bE: **884** Falstone 1cA (1:5): **885** Falstone 1cB (1:5): **886** Falstone 1cC (1:5): **887** Falstone 1cD/A (1:5): **888** Falstone 1cE (1:5).

889

890

891

892

893

894

895

Plate 166　**889** Falstone 2A (1:5): **890** Falstone 2A (1:5): **891** Falstone 2A (1:5): **892** Falstone 2C (1:5): **893** Falstone 2B (1:5): **894** Falstone 2D (1:5): **895** Falstone 2F (1:5).

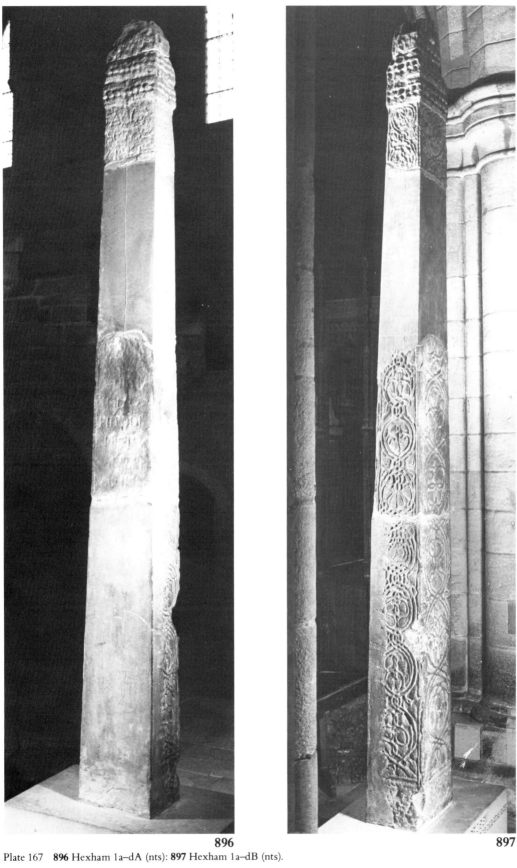

896

897

Plate 167　**896** Hexham 1a–dA (nts): **897** Hexham 1a–dB (nts).

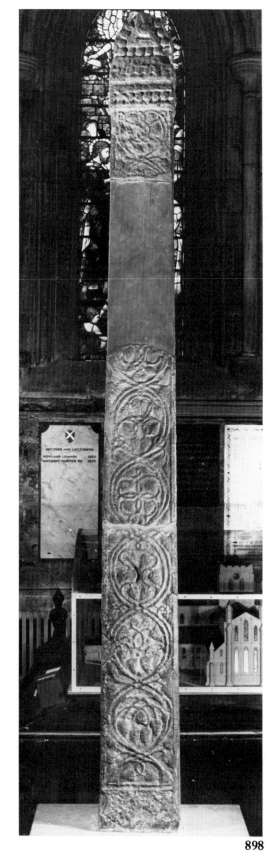

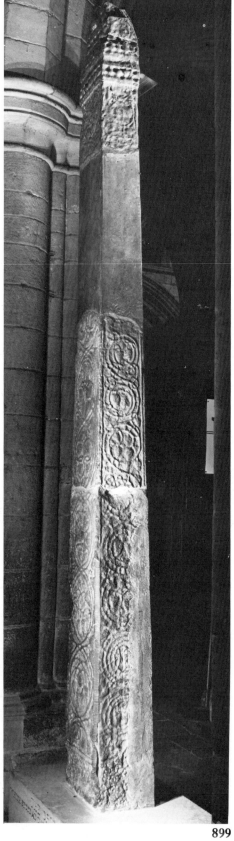

898

899

Plate 168 **898** Hexham 1a–dC (nts): **899** Hexham 1a–dD (nts).

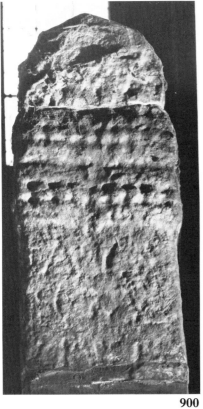

900

901

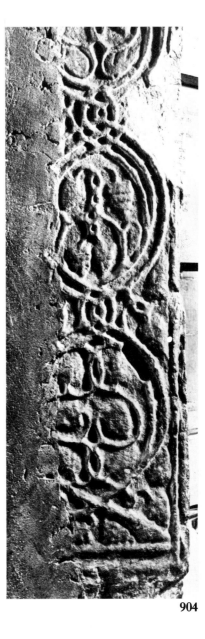

904

902

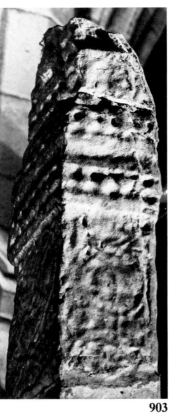

903

Plate 169 **900** Hexham 1a–bA: **901** Hexham 1a–bB: **902** Hexham
1a–bC: **903** Hexham 1a–bD: **904** Hexham 1dB (1:5).

905

906

Plate 170 **905** Hexham 1cA (1:5): **906** Hexham 1dC (1:5).

907

908

Plate 171 **907** Hexham 1dC/D (1:5): **908** Hexham 1dB/C (1:5).

909

910

911

912

913

Plate 172 **909** Hexham 1b–cC (1:5): **910** Hexham 8A: **911** Hexham
8B: **912** Hexham 8D: **913** Hexham 8C.

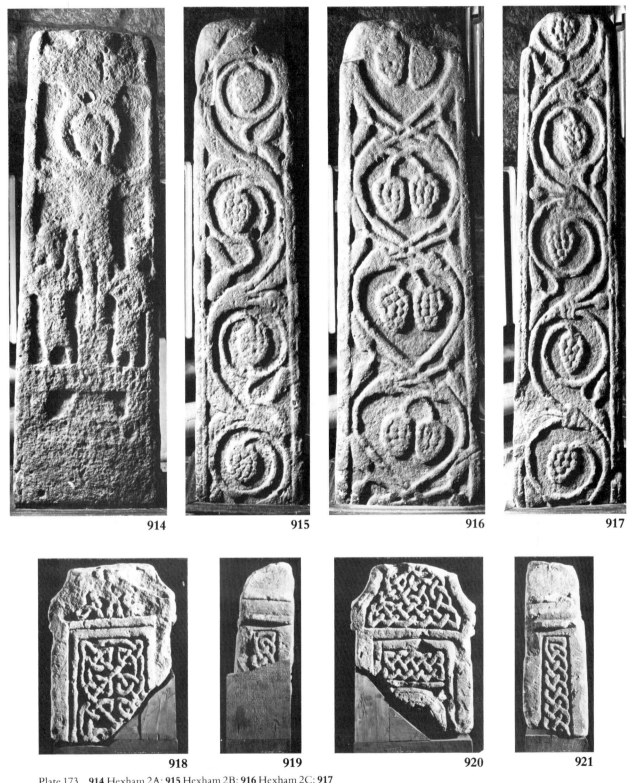

914

915

916

917

918

919

920

921

Plate 173 **914** Hexham 2A: **915** Hexham 2B: **916** Hexham 2C: **917** Hexham 2D: **918** Hexham 5A: **919** Hexham 5B: **920** Hexham 5C: **921** Hexham 5D.

922 923

924

Plate 174 **922** Hexham 3A (nts): **923** Hexham 3B (nts): **924** Hexham 3A (1:5).

927

925

926

Plate 175 **925** Hexham 3C (nts): **926** Hexham 3D (nts): **927** Hexham 3D (1:5).

928

933

929

930

931

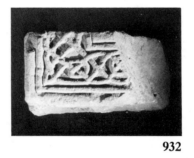

932

934

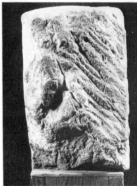

935

936

Plate 176 **928** Hexham 12A (1:5): **929** Hexham 12D/A/E: **930** Hexham 12A: **931** Hexham 12D: **932** Hexham 12E: **933** Hexham 4A (1:5): **934** Hexham 4B (1:5): **935** Hexham 4C (1:5): **936** Hexham 4D (1:5).

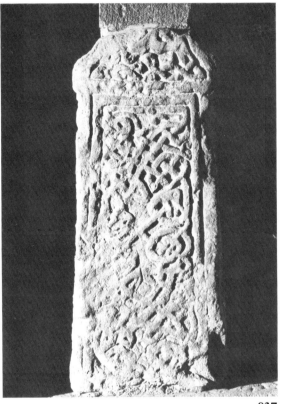

937

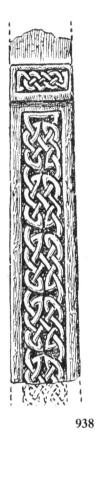

938

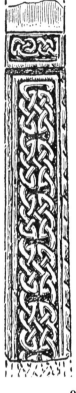

939

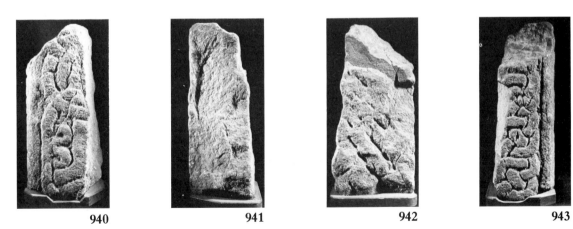

940 941 942 943

Plate 177 **937** Hexham 6A: **938** Hexham 6B (after Collingwood
1925): **939** Hexham 6D (after Collingwood 1925): **940** Hexham 7A:
941 Hexham 7B: **942** Hexham 7C: **943** Hexham 7D.

944

946

947

945

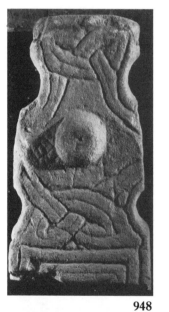

948

949

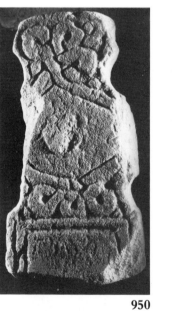

950

951

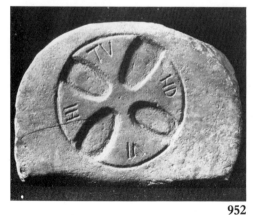

952

953

Plate 178 **944** Hexham 9A (after Collingwood 1925, nts): **945**
Hexham 9C (after Collingwood 1925, nts): **946** Hexham 10A: **947**
Hexham 10C: **948** Hexham 11A: **949** Hexham 11B: **950** Hexham
11C: **951** Hexham 11D: **952** Hexham 13A (1:5): **953** Hexham 13C
(1:5).

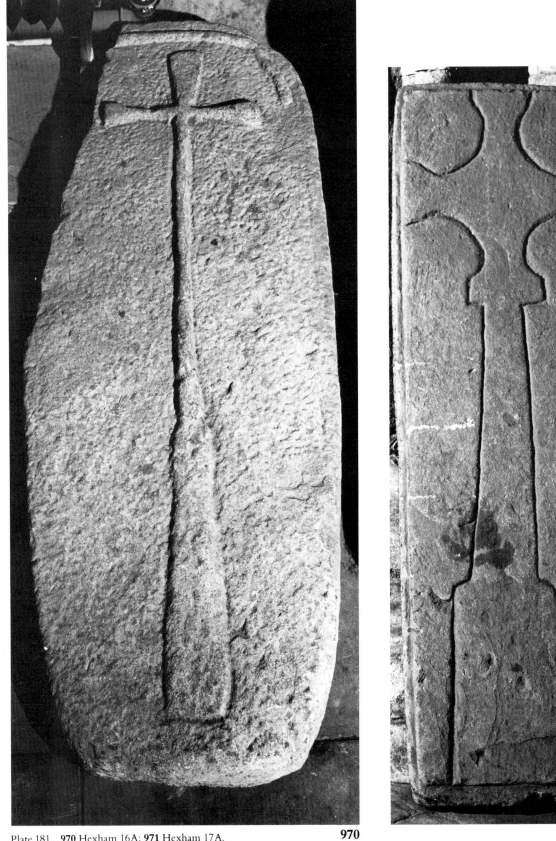

Plate 181 **970** Hexham 16A: **971** Hexham 17A.

970

971

972

973

974

975

976

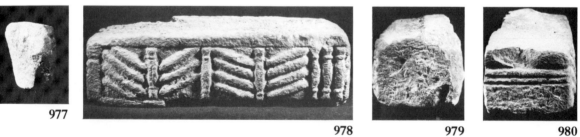

977

978

979

980

981

982

Plate 182 **972** Hexham 22A (1:5): **973** Hexham 23A: **974** Hexham
23A/B: **975** Hexham 23B: **976** Hexham 23C: **977** Hexham 23D: **978**
Hexham 24A: **979** Hexham 24B: **980** Hexham 24D: **981** Hexham
24C: **982** Hexham 24F.

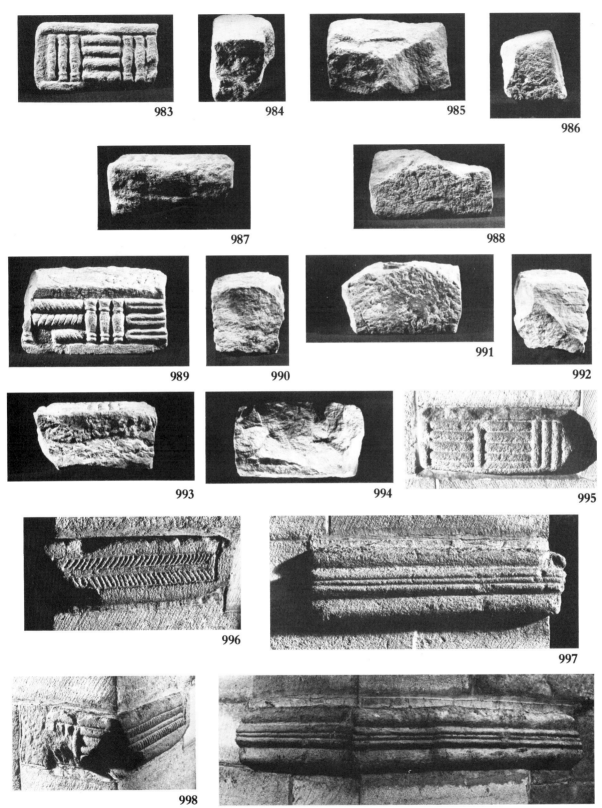

Plate 183 **983** Hexham 25A: **984** Hexham 25B: **985** Hexham 25C:
986 Hexham 25D: **987** Hexham 25F: **988** Hexham 25E: **989** Hexham
26A: **990** Hexham 26B: **991** Hexham 26E: **992** Hexham 26D: **993**
Hexham 26F: **944** Hexham 26C: **995** Hexham 27A: **996** Hexham
28A: **997** Hexham 29D: **998** Hexham 28D/A: **999** Hexham 29D/A.

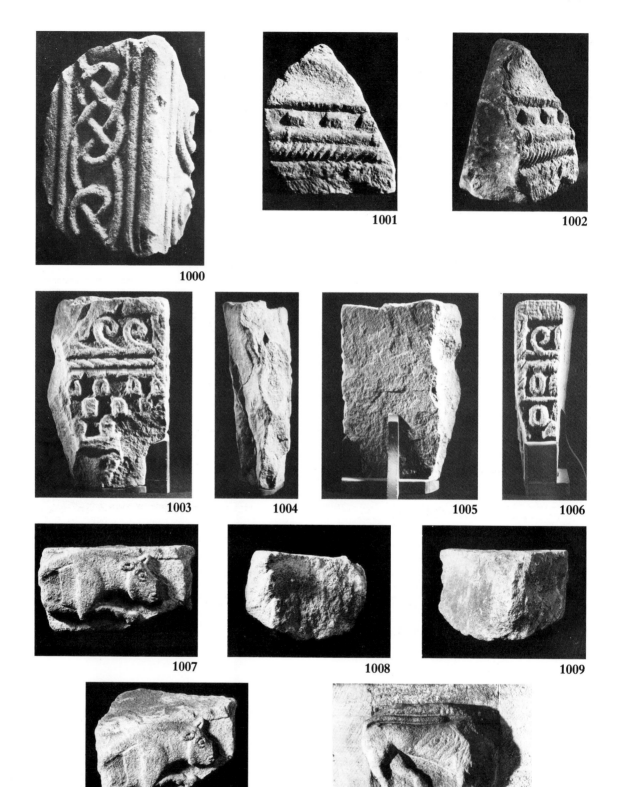

Plate 184 **1000** Hexham 30 (after Savage and Hodges 1907, nts):
1001 Hexham 31A (1:5): **1002** Hexham 31D/A (1:5): **1003** Hexham
32A: **1004** Hexham 32D: **1005** Hexham 32C/D: **1006** Hexham 32B:
1007 Hexham 33A: **1008** Hexham 33B/C: **1009** Hexham 33C/D:
1010 Hexham 33A/E: **1011** Hexham 35A.

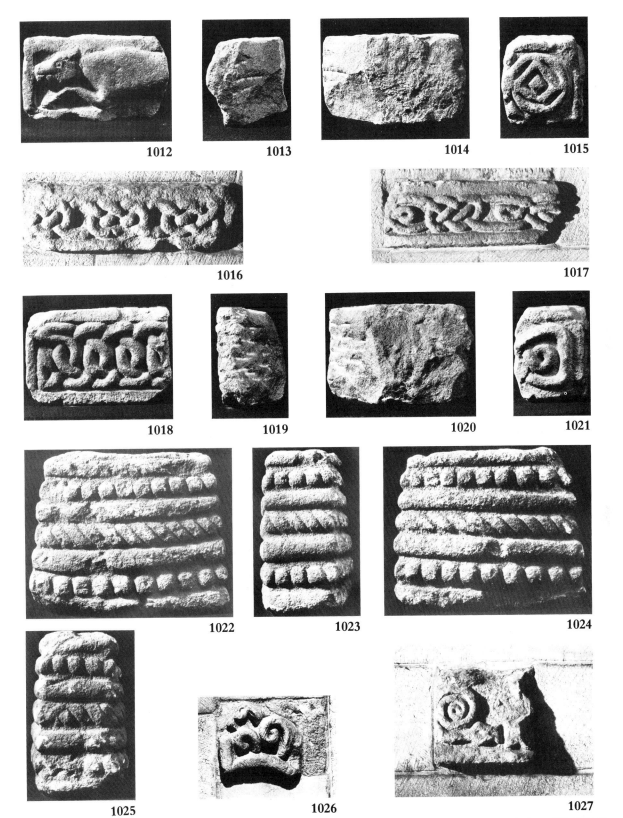

1012

1013

1014

1015

1016

1017

1018

1019

1020

1021

1022

1023

1024

1025

1026

1027

Plate 185 **1012** Hexham 34A: **1013** Hexham 34B: **1014** Hexham 34B/C: **1015** Hexham 34D: **1016** Hexham 36A: **1017** Hexham 37A: **1018** Hexham 38A: **1019** Hexham 38B: **1020** Hexham 38B/C: **1021** Hexham 38D: **1022** Hexham 40A: **1023** Hexham 40B: **1024** Hexham 40C: **1025** Hexham 40D: **1026** Hexham 43: **1027** Hexham 39

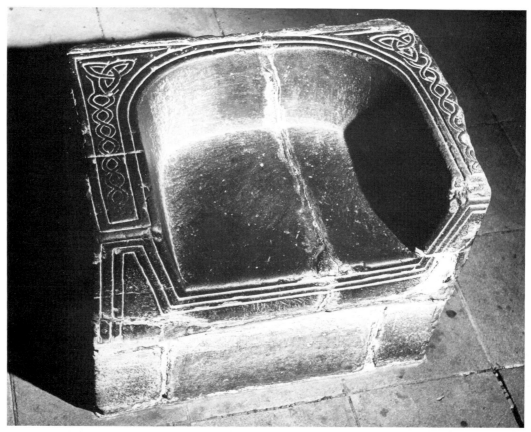

1028

1029

Plate 186 **1028** Hexham 41A/E: **1029** Hexham 41C.

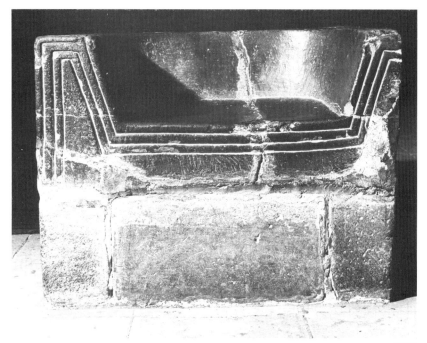

1030

1031

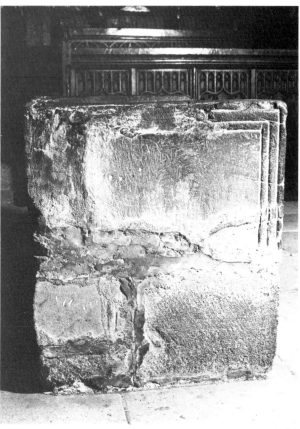

1032

Plate 187 **1030** Hexham 41A: **1031** Hexham 41B: **1032** Hexham
41D.

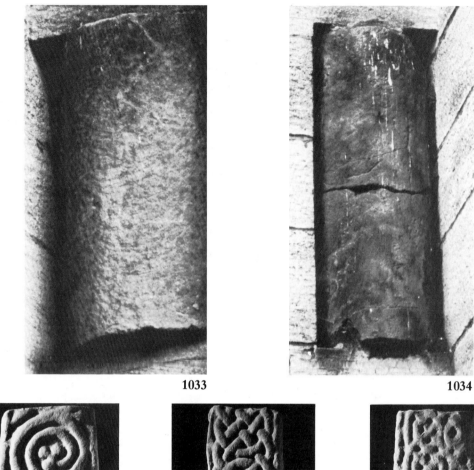

1033 **1034**

1035 **1036** **1037**

1038 **1039**

Plate 188 **1033** Hexham 42a: **1034** Hexham 42b–c: **1035** Hulne
Priory 1A: **1036** Hulne Priory 1B: **1037** Hulne Priory 1C: **1038**
Hulne Priory 1D: **1039** Lindisfarne 1A (top turned to right, 1:5).

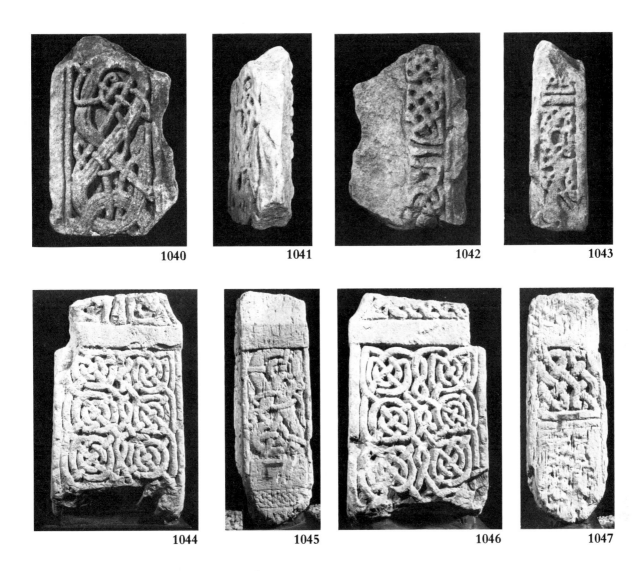

1040 1041 1042 1043

1044 1045 1046 1047

1048 1049

Plate 189 **1040** Lindisfarne 1A: **1041** Lindisfarne 1B: **1042** Lindis-
farne 1C: **1043** Lindisfarne 1D: **1044** Lindisfarne 2A: **1045** Lindis-
farne 2B: **1046** Lindisfarne 2C: **1047** Lindisfarne 2D: **1048** Lindis-
farne 4A: **1049** Lindisfarne 4E.

1051

1050

1052 **1053** **1054**

Plate 190 **1050** Lindisfarne 3A: **1051** Lindisfarne 3A (1:5): **1052**
Lindisfarne 3B: **1053** Lindisfarne 3C: **1054** Lindisfarne 3D.

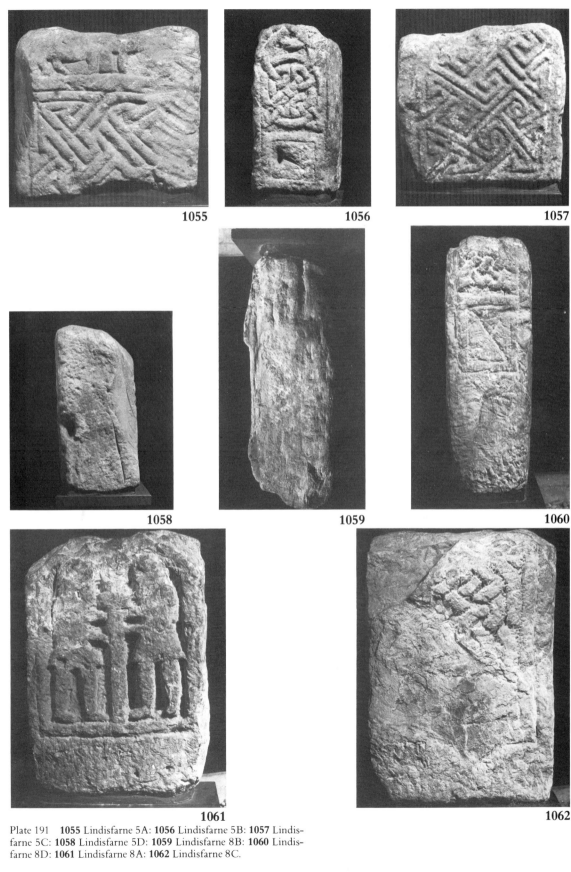

1055 1056 1057

1058 1059 1060

1061 1062

Plate 191 **1055** Lindisfarne 5A: **1056** Lindisfarne 5B: **1057** Lindis-
farne 5C: **1058** Lindisfarne 5D: **1059** Lindisfarne 8B: **1060** Lindis-
farne 8D: **1061** Lindisfarne 8A: **1062** Lindisfarne 8C.

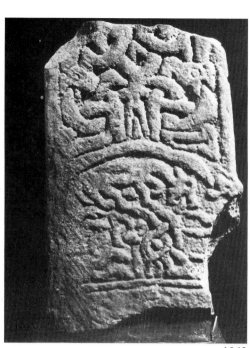

1063

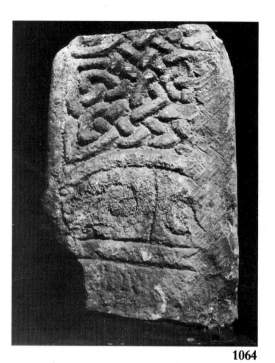

1064

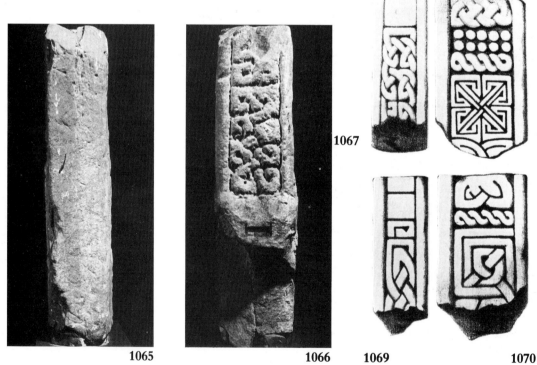

1065

1066

1067

1068

1069

1070

Plate 192 **1063** Lindisfarne 7 A: **1064** Lindisfarne 7 C: **1065** Lindis-
farne 7B: **1066** Lindisfarne 7D: **1067** Lindisfarne 11D (after Stuart
1867): **1068** Lindisfarne 11A (after Stuart 1867): **1069** Lindisfarne
11B (after Stuart 1867): **1070** Lindisfarne 11C (after Stuart 1867).

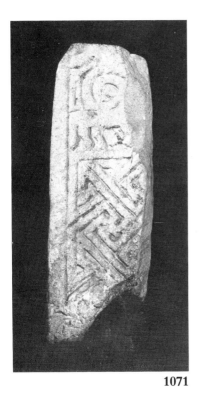

1071

1072

1075

1076

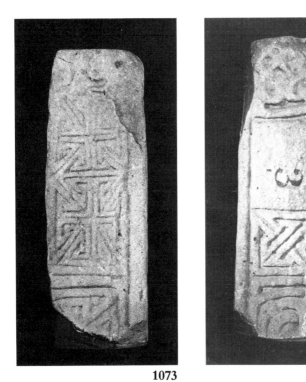

1073

1074

1077

Plate 193 **1071** Lindisfarne 6A: **1072** Lindisfarne 6B: **1073** Lindis-
farne 6C: **1074** Lindisfarne 6D: **1075** Lindisfarne 14A (1:5): **1076**
Lindisfarne 14C (1:5): **1077** Lindisfarne 14D (1:5).

1078

1079

1082

1080

1083

1084

1081

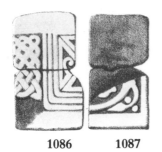

1086 1087

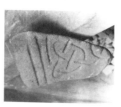

1088

1085

Plate 194 **1078** Lindisfarne 9A: **1079** Lindisfarne 9B: **1080** Lindis-
farne 9C: **1081** Lindisfarne 9D: **1082** Lindisfarne 16A: **1083** Lindis-.
farne 16B: **1084** Lindisfarne 16C: **1085** Lindisfarne 16D: **1086** Lindis-
farne 12A (after Stuart 1867): **1087** Lindisfarne 12B (after Stuart
1867): **1088** Lindisfarne 10A (nts).

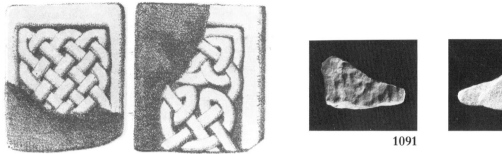

1089 1090

1091 1092

1095

1096

1093

1094

1097

1098

1099

1100

1101

1102

Plate 195 **1089** Lindisfarne 13B (after Stuart 1867, 1:5): **1090** Lindisfarne 13A (after Stuart 1867, 1:5): **1091** Lindisfarne 15bA (1:5): **1092** Lindisfarne 15bC (1:5): **1093** Lindisfarne 15bE (1:5): **1094** Lindisfarne 15bF (1:5): **1095** Lindisfarne 15aA/E (1:5): **1096** Lindisfarne 15aA (1:5): **1097** Lindisfarne 17A: **1098** Lindisfarne 17D: **1099** Lindisfarne 18A: **1100** Lindisfarne 18B: **1101** Lindisfarne 18C: **1102** Lindisfarne 18D.

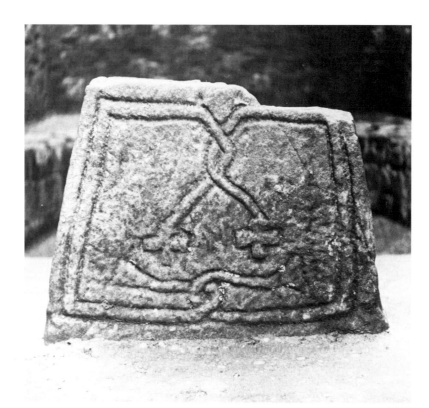

1103

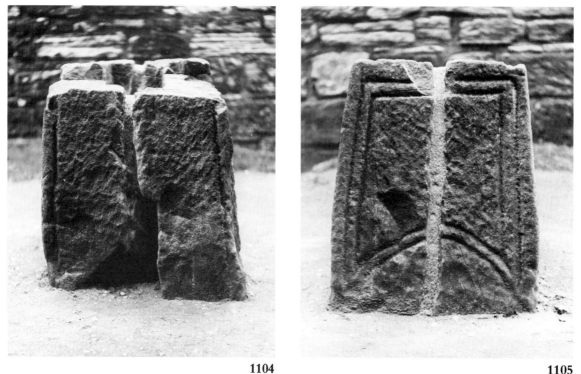

1104

1105

Plate 196 **1103** Lindisfarne 19A: **1104** Lindisfarne 19B: **1105** Lindisfarne 19D.

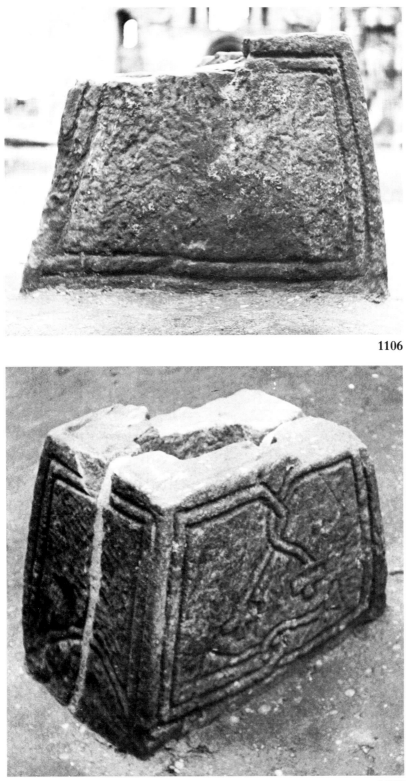

1106

1107

Plate 197 **1106** Lindisfarne 19C: **1107** Lindisfarne 19D/A/E.

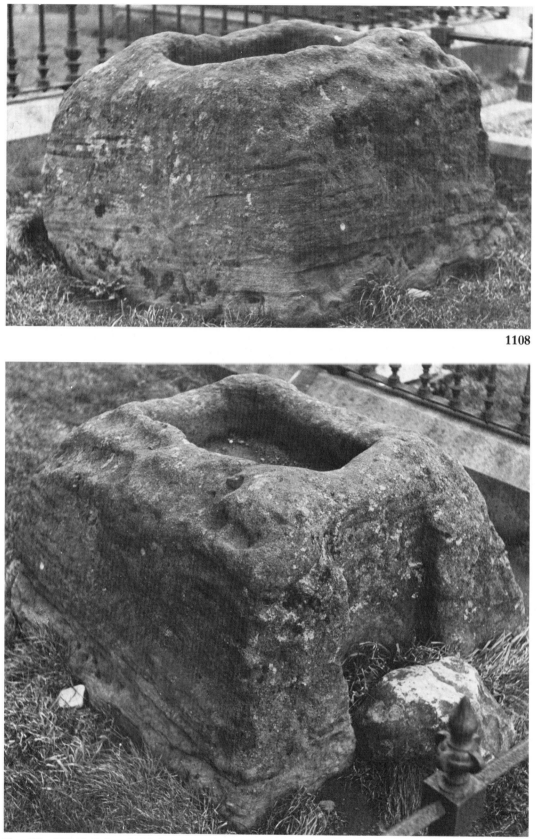

1108

1109

Plate 198 **1108** Lindisfarne 21C/D/E: **1109** Lindisfarne 21A/B/E.

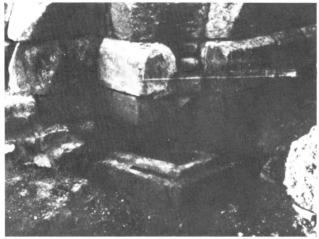

1111

1110

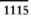

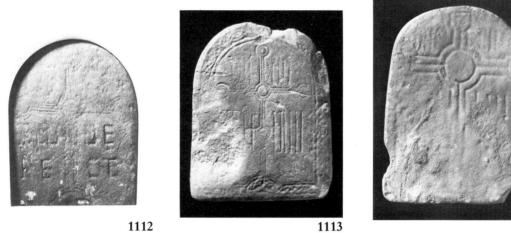

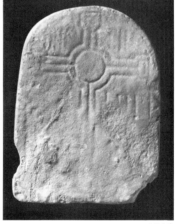

1112 1113 1114

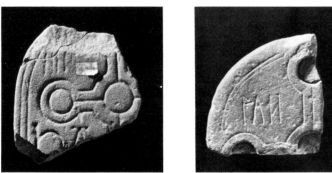

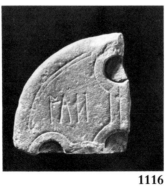

1115 1116 1117

Plate 199 **1110** Lindisfarne 20A/B/E (after Peers 1923–4, nts): **1111** Lindisfarne 22A (1:5): **1112** Lindisfarne 23A (1:5): **1113** Lindisfarne 29A (1:5): **1114** Lindisfarne 31A (1:5): **1115** Lindisfarne 26A (1:5): **1116** Lindisfarne 27A (1:5): **1117** Lindisfarne 27C (1:5).

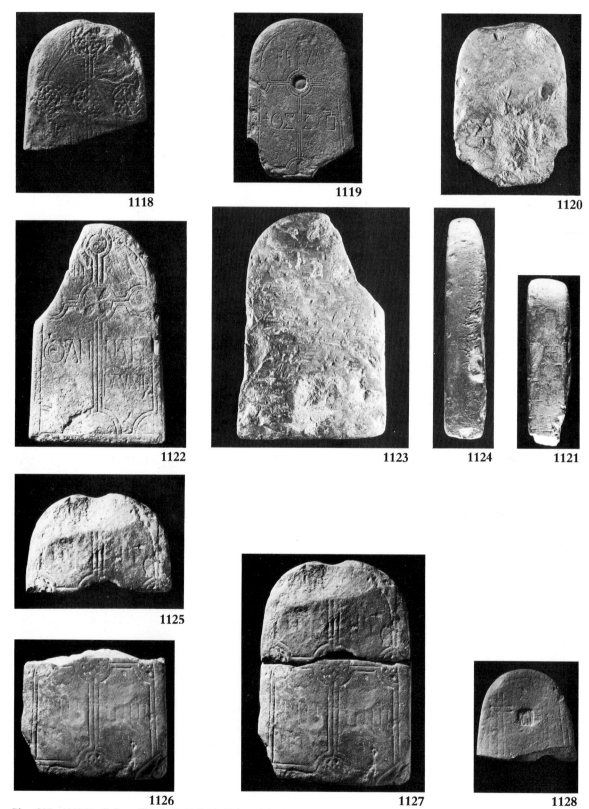

1118
1119
1120
1122
1123
1124
1121
1125
1126
1127
1128

Plate 200 **1118** Lindisfarne 28A (1:5): **1119** Lindisfarne 24A (1:5):
1120 Lindisfarne 24C (1:5): **1121** Lindisfarne 24B (1:5): **1122** Lindis-
farne 25A (1:5): **1123** Lindisfarne 25C (1:5): **1124** Lindisfarne 25B
(1:5): **1125** Lindisfarne 30aA (1:5): **1126** Lindisfarne 30bA (1:5): **1127**
Lindisfarne 30a–bA (1:5): **1128** Lindisfarne 33A (1:5).

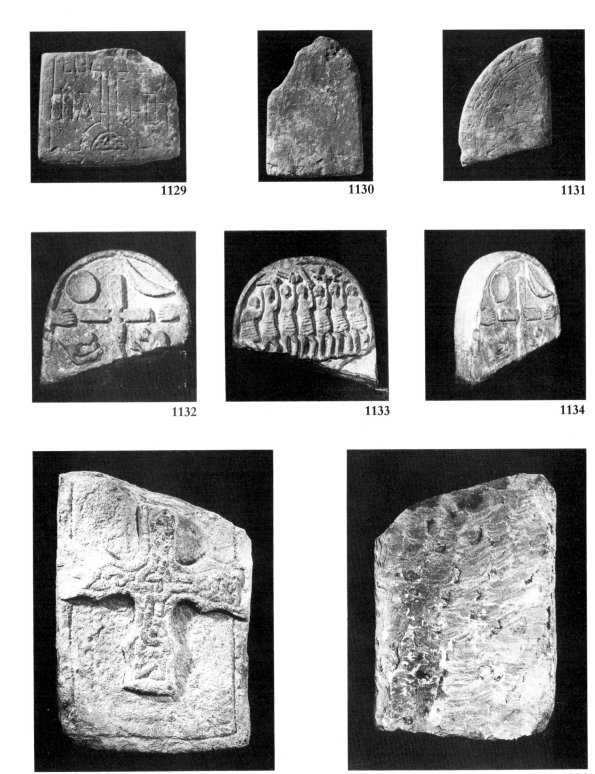

1129

1130

1131

1132

1133

1134

1135

1136

Plate 201 **1129** Lindisfarne 32A (1:5): **1130** Lindisfarne 34 (1:5):
1131 Lindisfarne 36A (1:5): **1132** Lindisfarne 37A: **1133** Lindisfarne
37C: **1134** Lindisfarne 37D/A: **1135** Lindisfarne 38A: **1136** Lindis-
farne 38F.

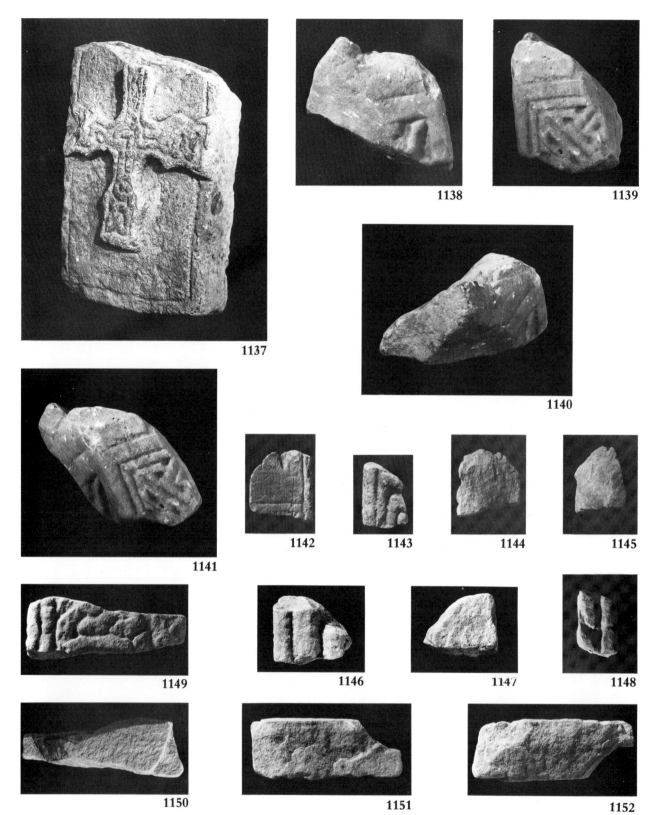

Plate 202 **1137** Lindisfarne 38A/B: **1138** Lindisfarne 39D (nts): **1139** Lindisfarne 39A (nts): **1140** Lindisfarne 39C/D (nts): **1141** Lindisfarne 39D/A (nts): **1142** Lindisfarne 40A (1:5): **1143** Lindisfarne 40B (1:5): **1144** Lindisfarne 40C (1:5): **1145** Lindisfarne 40C/D (1:5): **1146** Lindisfarne 41A (1:5): **1147** Lindisfarne 41C (1:5): **1148** Lindisfarne 41D (1:5): **1149** Lindisfarne 42A (1:5): **1150** Lindisfarne 42C (1:5): **1151** Lindisfarne 42E (1:5): **1152** Lindisfarne 42F (1:5).

1153 **1154** **1155** **1156**

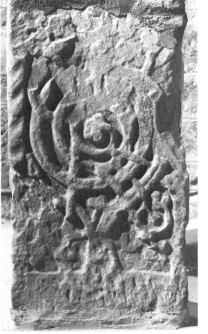

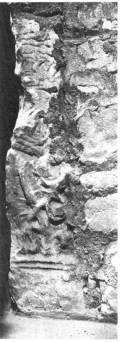

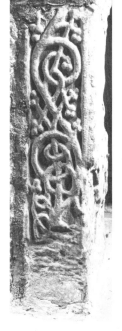

1157 **1158** **1159**

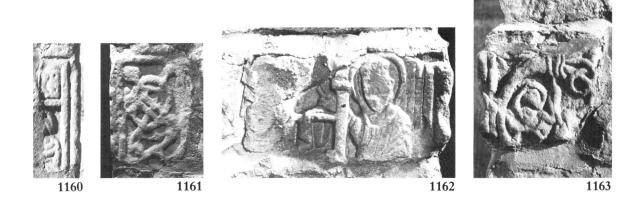

1160 **1161** **1162** **1163**

Plate 203 **1153** Lindisfarne 43A: **1154** Lindisfarne 43B: **1155** Lindisfarne 43C: **1156** Lindisfarne 43D: **1157** Norham 1A: **1158** Norham 1B: **1159** Norham 1D: **1160** Norham 2A: **1161** Norham 2B: **1162** Norham 4A (1:5): **1163** Norham 4B (1:5).

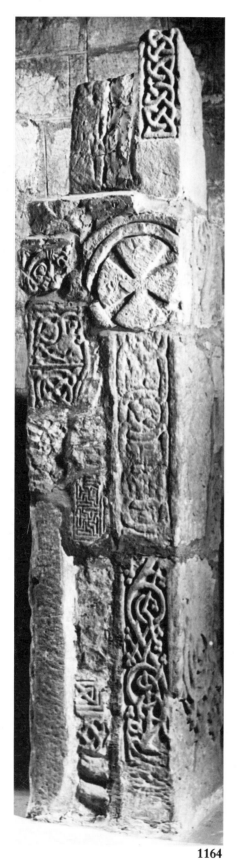

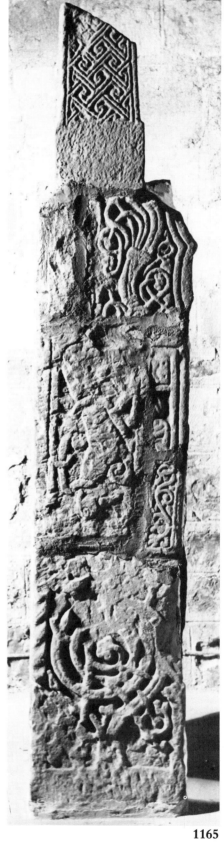

1164

1165

Plate 204 **1164** Norham pillar (east face, nts): **1165** Norham pillar (north face, nts).

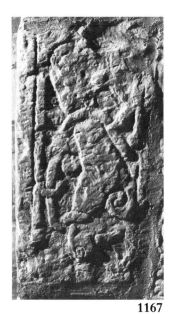

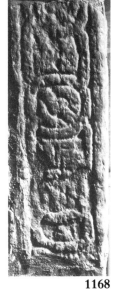

1167 **1168**

1169 **1170**

1171

1172 **1173**

1166

Plate 205 **1166** Norham pillar (south face, nts): **1167** Norham 3A:
1168 Norham 3D: **1169** Norham 7aA: **1170** Norham 7bA (1:5): **1171**
Norham 8b (after Stuart 1867, 1:5): **1172** Norham 8aB (1:5): **1173**
Norham 6 (1:5).

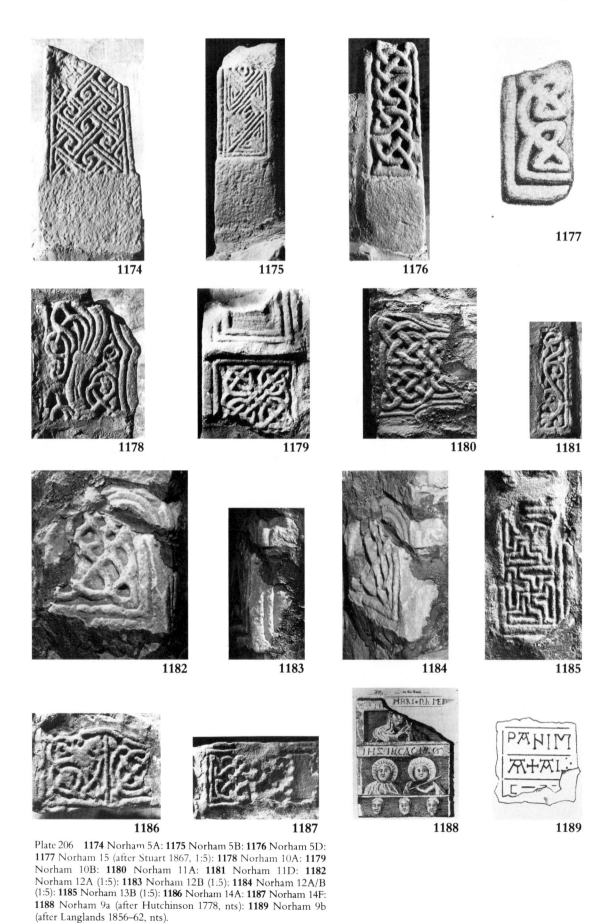

Plate 206 **1174** Norham 5A: **1175** Norham 5B: **1176** Norham 5D:
1177 Norham 15 (after Stuart 1867, 1:5): **1178** Norham 10A: **1179**
Norham 10B: **1180** Norham 11A: **1181** Norham 11D: **1182**
Norham 12A (1:5): **1183** Norham 12B (1:5): **1184** Norham 12A/B
(1:5): **1185** Norham 13B (1:5): **1186** Norham 14A: **1187** Norham 14F:
1188 Norham 9a (after Hutchinson 1778, nts): **1189** Norham 9b
(after Langlands 1856–62, nts).

1190

1191

1192

Plate 207 **1190** Norham 16A: **1191** Norham 16D: **1192** Nunnykirk
1A (1:5).

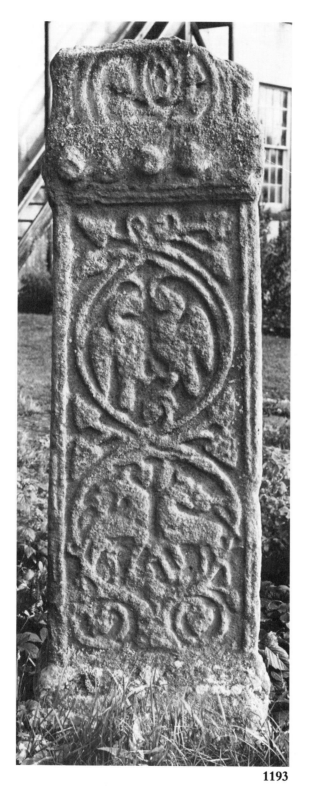

1193

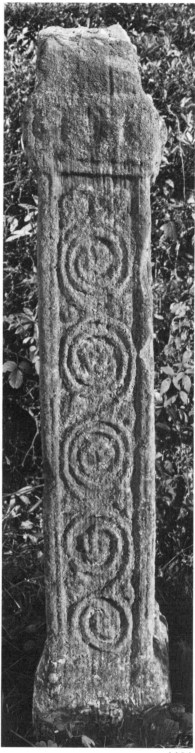

1194

Plate 208 **1193** Nunnykirk 1A: **1194** Nunnykirk 1B.

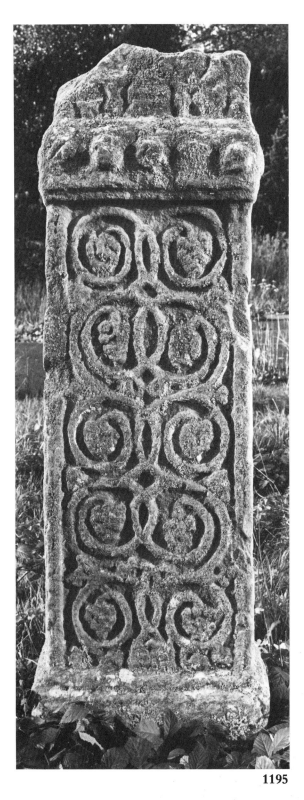

1195

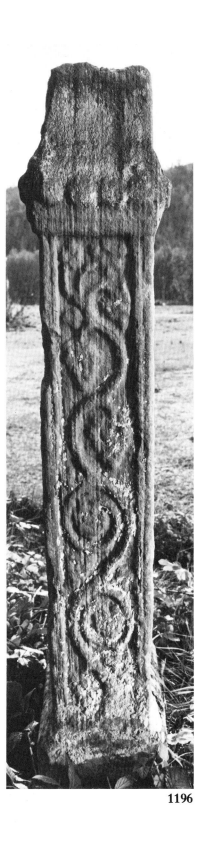

1196

Plate 209 **1195** Nunnykirk 1C: **1196** Nunnykirk 1D.

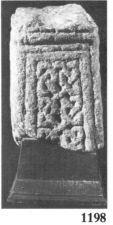

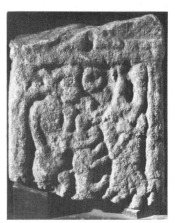

1197 **1198** **1199**

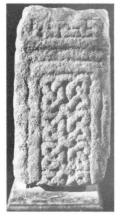

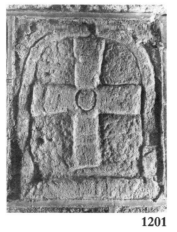

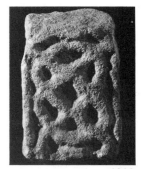

1200 **1201** **1202**

1203 **1204** **1205**

Plate 210 **1197** Ovingham 1A: **1198** Ovingham 1B: **1199** Oving-
ham 1C: **1200** Ovingham 1D: **1201** Ponteland 1A: **1202** Ovingham
2A: **1203** Ovingham 2B: **1204** Ovingham 2C: **1205** Ovingham 2D.

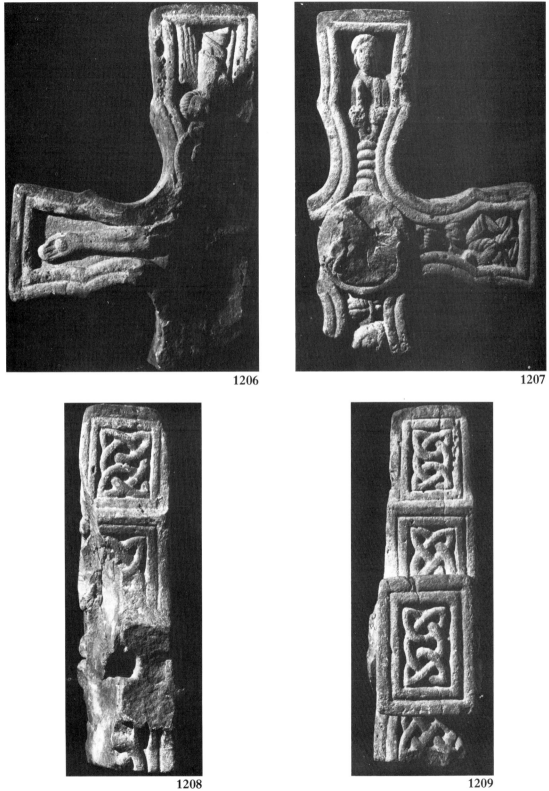

1206

1207

1208

1209

Plate 211 **1206** Rothbury 1aA: **1207** Rothbury 1aC: **1208** Rothbury 1aB: **1209** Rothbury 1aD.

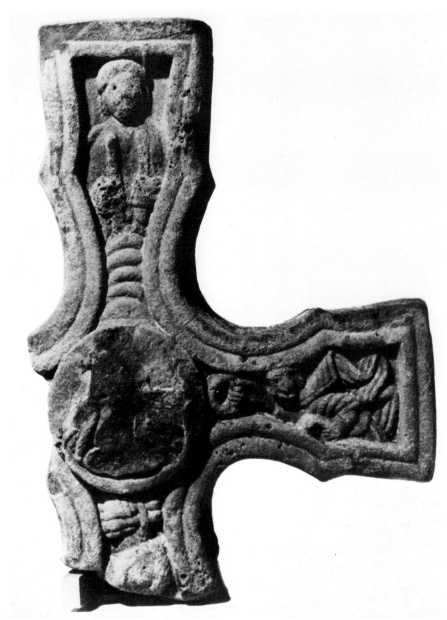

1210

1211

1212

Plate 212 **1210** Rothbury 1aC (1:5): **1211** Rothbury 1aE: **1212** Rothbury 1aF.

1213

1214

1215

1216

1217

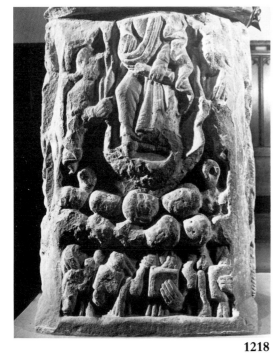
1218

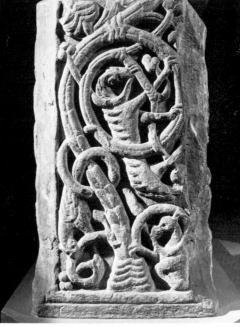
1219

Plate 213　**1213** Rothbury 1bA: **1214** Rothbury 1bB: **1215** Rothbury 1bC: **1216** Rothbury 1bD: **1217** Rothbury 1bE: **1218** Rothbury 1cA: **1219** Rothbury 1cB.

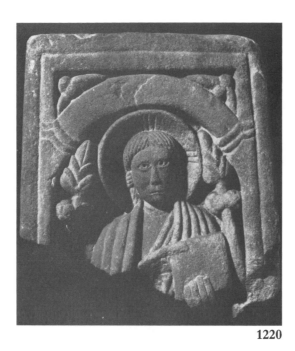

1220

1221

1222

1223

Plate 214 **1220** Rothbury 1bA (1:5): **1221** Rothbury 1bD (1:5):
1222 Rothbury 1cC: **1223** Rothbury 1cD.

1225

1224

1226

Plate 215 **1224** Rothbury 1cD (1:5): **1225** Rothbury 2a–bA: **1226** St
Oswald-in-Lee 1A/E.

1227

1228

Plate 216 **1227** St Oswald-in-Lee 1A/B: **1228** St Oswald-in-Lee 1D/A.

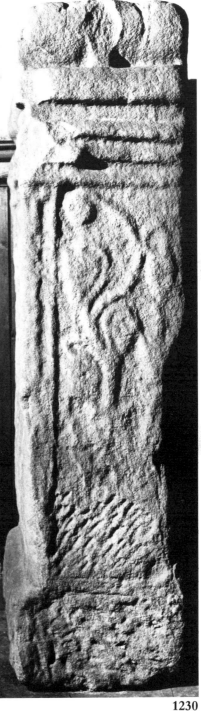

1229

1230

Plate 217 **1229** St Oswald-in-Lee 2A: **1230** St Oswald-in-Lee 2B.

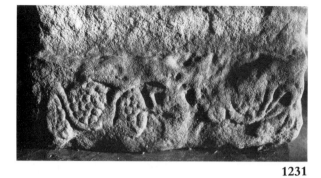

1231

1232

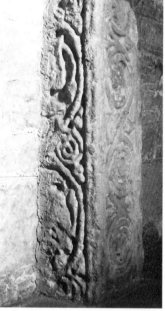

1233

1234

1235

1236

1237

1238

1239

Plate 218 **1231** St Oswald-in-Lee 2A: **1232** St Oswald-in-Lee 2E: **1233** Simonburn 1A/B: **1234** Simonburn 1B: **1235** Simonburn 1B/C: **1236** Simonburn 3A: **1237** Simonburn 3A/B: **1238** Simonburn 4A: **1239** Simonburn 2A.

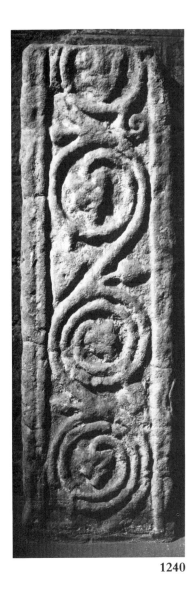

1240

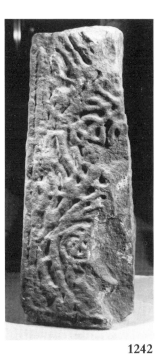

1242

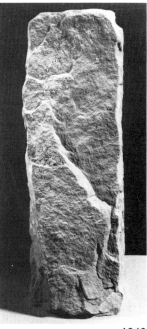

1243

1241

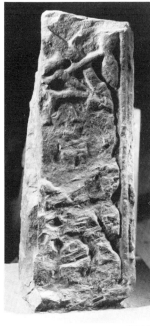

1244

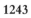

1245

Plate 219 **1240** Simonburn 1B (1:5): **1241** Simonburn 5: **1242** Stamfordham 1A: **1243** Stamfordham 1B: **1244** Stamfordham 1C: **1245** Stamfordham 1D.

1246 **1247** **1248** **1249**

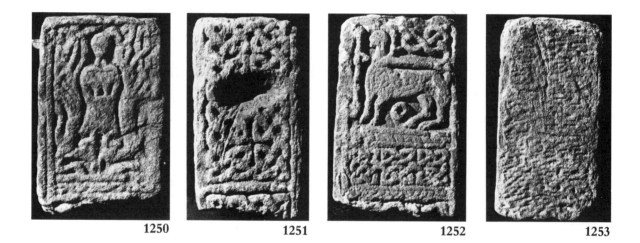

1250 **1251** **1252** **1253**

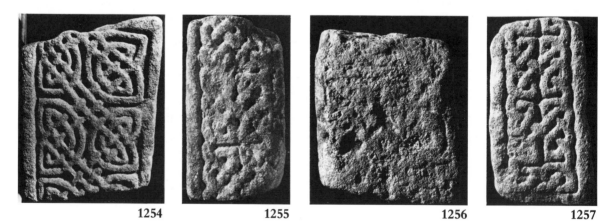

1254 **1255** **1256** **1257**

Plate 220 **1246** South Tyne 1A: **1247** South Tyne 1B: **1248** South Tyne 1C: **1249** South Tyne 1D: **1250** Tynemouth 2A: **1251** Tynemouth 2B: **1252** Tynemouth 2C: **1253** Tynemouth 2D: **1254** Tynemouth 3A: **1255** Tynemouth 3B: **1256** Tynemouth 3C: **1257** Tynemouth 3D.

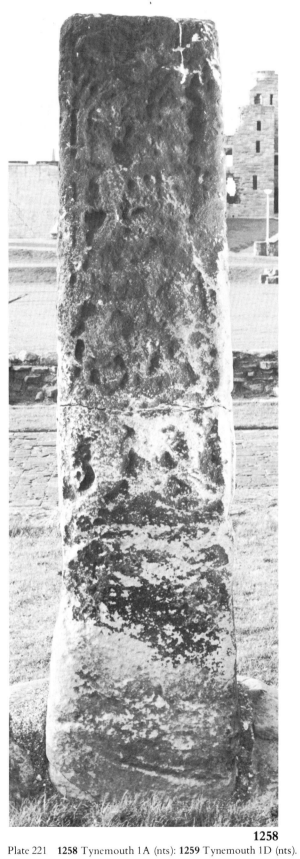

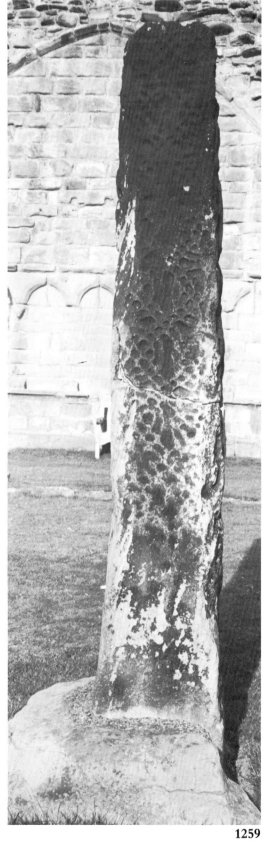

1258 **1259**

Plate 221 **1258** Tynemouth 1A (nts): **1259** Tynemouth 1D (nts).

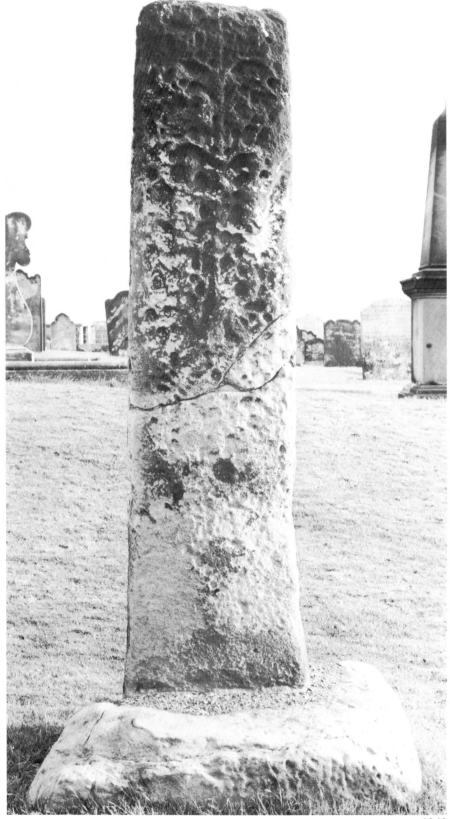

Plate 222 **1260** Tynemouth 1C (nts).

1260

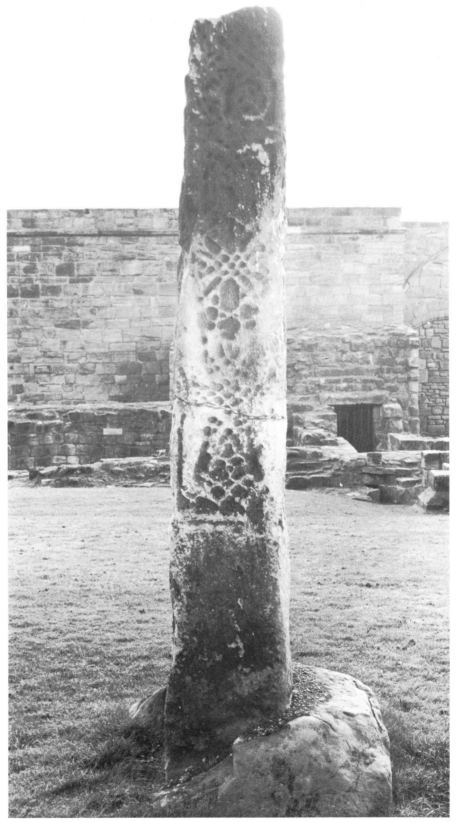

Plate 223 **1261** Tynemouth 1B (nts).

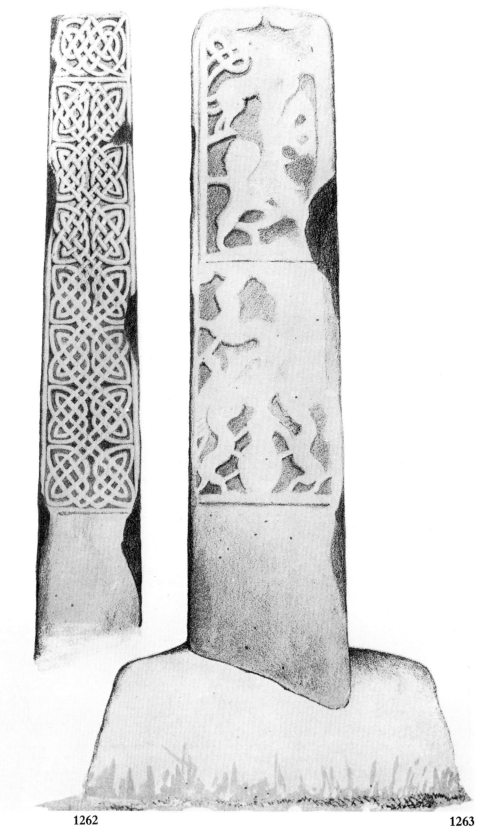

1262

1263

Plate 224 **1262** Tynemouth 1D (after Stuart 1867, nts): **1263** Tynemouth 1A (after Stuart 1867, nts).

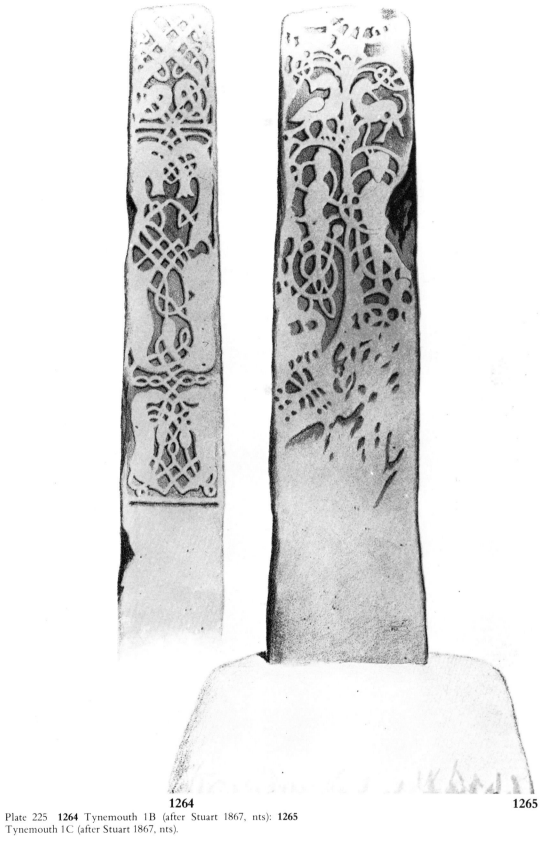

1264

1265

Plate 225 **1264** Tynemouth 1B (after Stuart 1867, nts): **1265**
Tynemouth 1C (after Stuart 1867, nts).

1266

1267

1268

1269

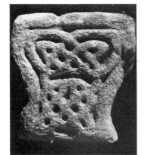

1270

1271

1272

1273

1274

1275

1276

1277

Plate 226 **1266** Tynemouth 4A: **1267** Tynemouth 4C: **1268** Tynemouth 4D: **1269** Tynemouth 4F: **1270** Tynemouth 5A (1:5): **1271** Tynemouth 5B (1:5): **1272** Tynemouth 5C (1:5): **1273** Tynemouth 5D (1:5): **1274** Tynemouth 6A: **1275** Tynemouth 6B: **1276** Tynemouth 6C: **1277** Tynemouth 6D.

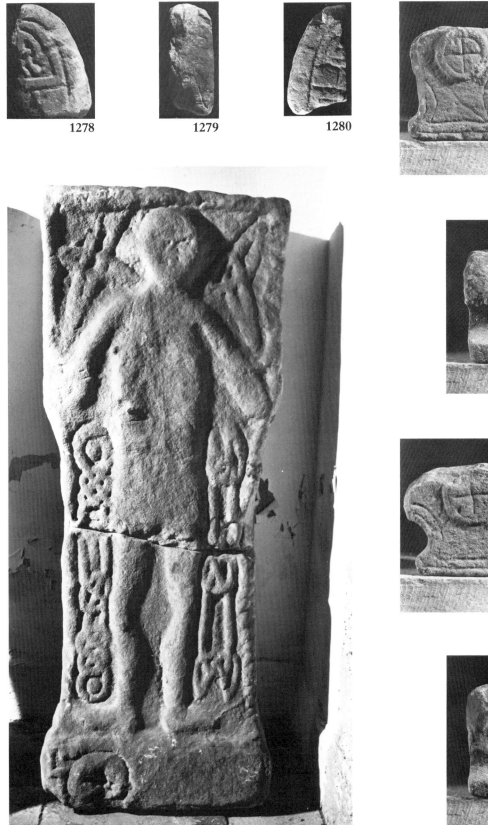

1278 1279 1280

1282

1283

1284

1285

1281

Plate 227 **1278** Tynemouth 7A: **1279** Tynemouth 7B: **1280**
Tynemouth 7C: **1281** Warden 1A: **1282** Warkworth 1A: **1283**
Warkworth 1B: **1284** Warkworth 1C: **1285** Warkworth 1D.

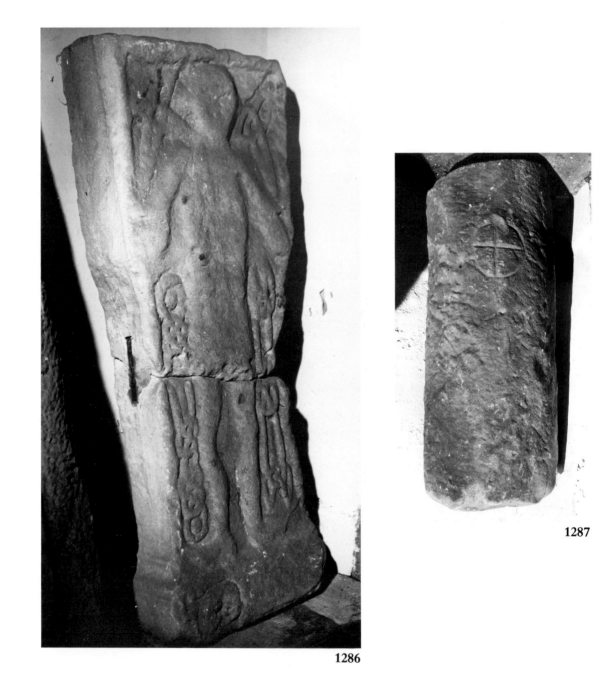

1286

1287

Plate 228 **1286** Warden 1D/A: **1287** Warden 2.

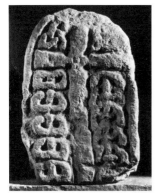
1288

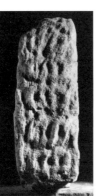
1289

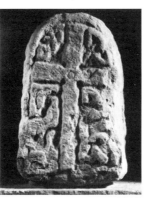
1290

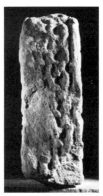
1291

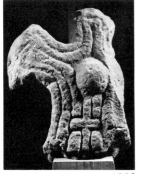
1292

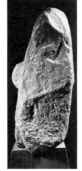
1293

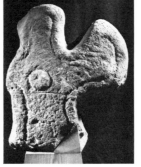
1294

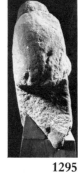
1295

1296

1297

1298

1299

1300

1301

Plate 229 **1288** Warkworth 2A: **1289** Warkworth 2B: **1290** Warkworth 2C: **1291** Warkworth 2D: **1292** Wooler 1A: **1293** Wooler 1B: **1294** Wooler 1C: **1295** Wooler 1D: **1296** Unknown Provenance 1A (1:5): **1297** Unknown Provenance 1C (1:5): **1298** Unknown Provenance 1D (1:5): **1299** Unknown Provenance 2A: **1300** Unknown Provenance 2B: **1301** Unknown Provenance 2C.

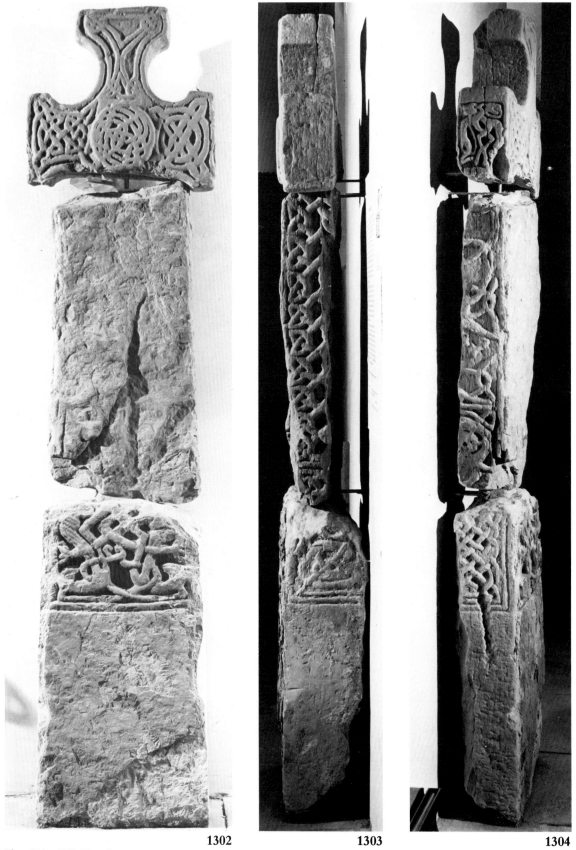

1302 **1303** **1304**

Plate 230 **1302** Woodhorn 1a–cA (nts): **1303** Woodhorn 1a–cB
(nts): **1304** Woodhorn 1a–cD (nts).

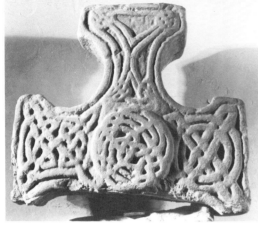

1305

1306

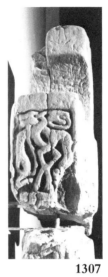

1307

1308

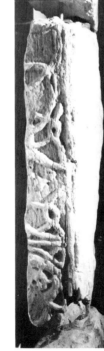

1309

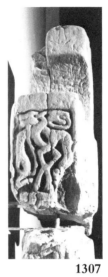

1310

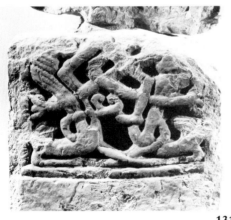

1311

Plate 231 **1305** Woodhorn 1aA: **1306** Woodhorn 1aB: **1307** Woodhorn 1aD: **1308** Woodhorn 1aC: **1309** Woodhorn 1bB: **1310** Woodhorn 1bD: **1311** Woodhorn 1cA.

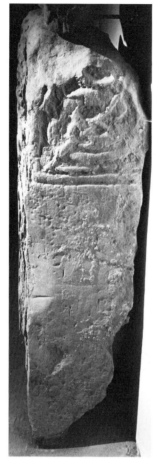

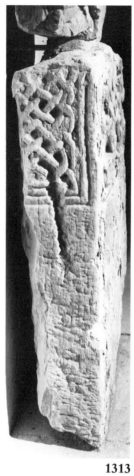

1314

1312

1313

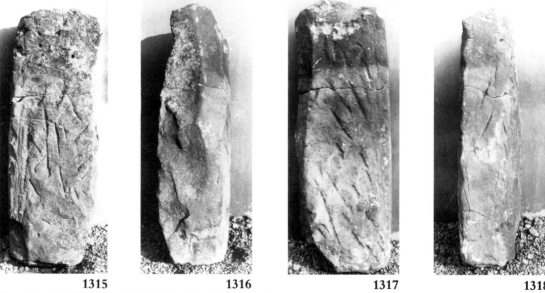

1315

1316

1317

1318

Plate 232　**1312** Woodhorn 1cB: **1313** Woodhorn 1cD: **1314** Birtley
3A: **1315** Wooler 2A: **1316** Wooler 2B: **1317** Wooler 2C: **1318**
Wooler 2D.

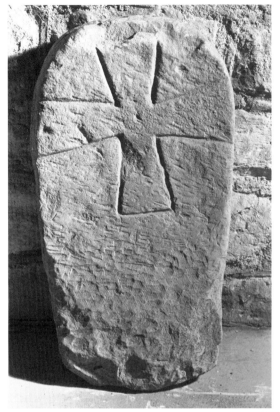

1319

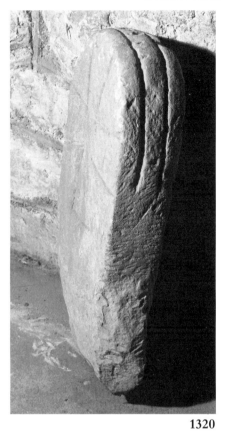

1320

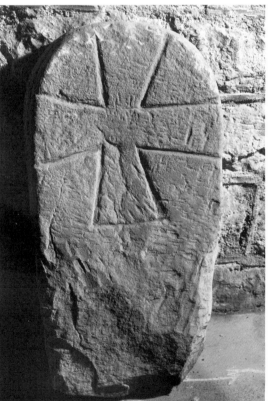

1321

Plate 233 **1319** Bolam 1A: **1320** Bolam 1A/B: **1321** Bolam 1C.

1322

1323

1324

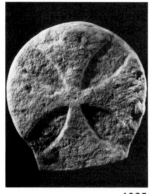

1325

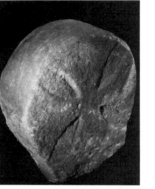

1326

1327

1328

1329

1330

1331

1332

Plate 234 **1322** Unknown Provenance 3A: **1323** Unknown Provenance 3C: **1324** Unknown Provenance 3D: **1325** Birtley 4A: **1326** Birtley 4B/C/E: **1327** Birtley 4C: **1328** Bolam 3aA: **1329** Bolam 3aA/B: **1330** Bolam 3bA: **1331** Chollerton 2A (nts): **1332** Corbridge 1A.

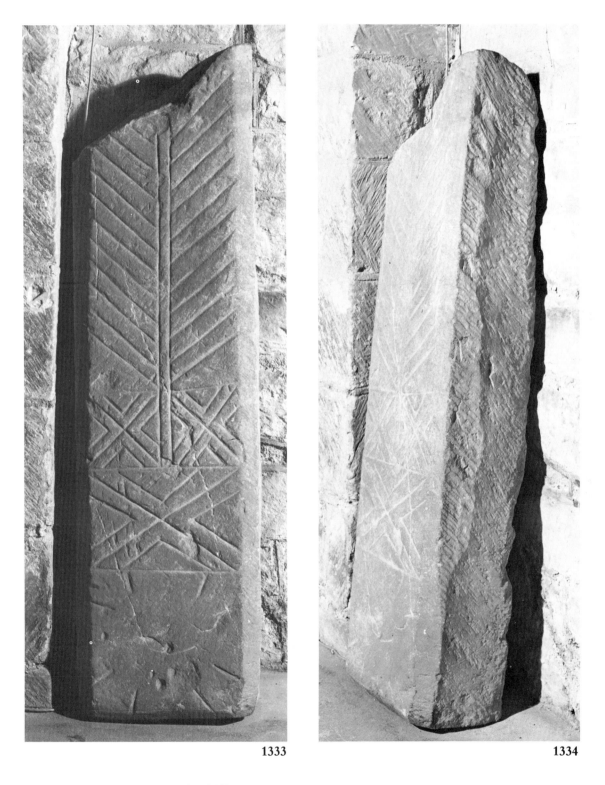

1333

1334

Plate 235 **1333** Bolam 2A: **1334** Bolam 2A/B.

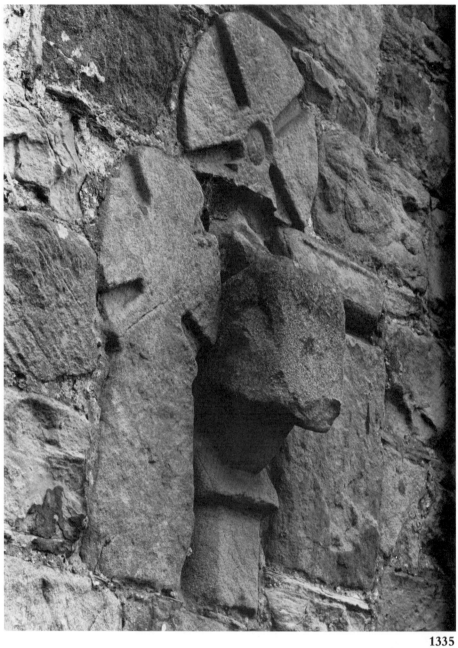

1335

Plate 236　**1335** Chollerton 1A, 2A, 3/A/B (nts).

1336

1337

1338

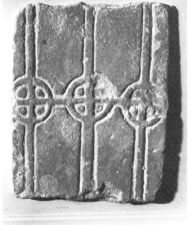

1341

1339

1340

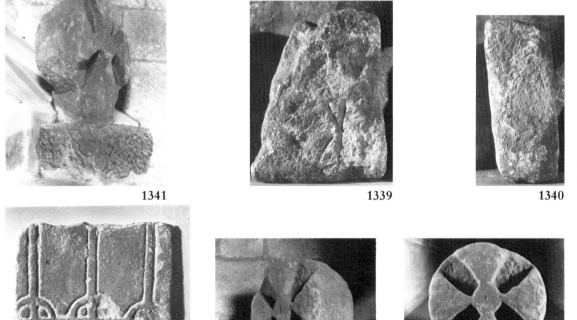

1344

1342

1343

Plate 237 **1336** Chollerton 1A (nts): **1337** Corbridge 4A: **1338**
Corbridge 4B: **1339** Corbridge 4C: **1340** Corbridge 4D: **1341**
Heddon-on-the-Wall 1D/A: **1342** Heddon-on-the-Wall 1A/B: **1343**
Heddon-on-the-Wall 1A: **1344** Corbridge 2.

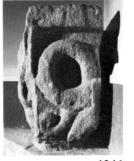

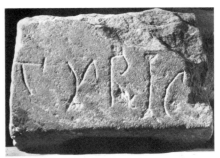

1345 **1346** **1347**

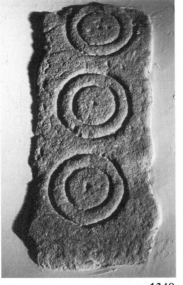

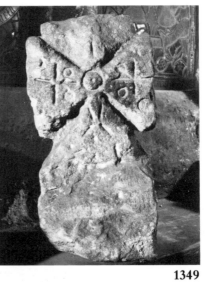

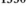

1348 **1349** **1350**

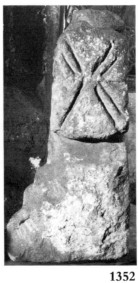

1351 **1352**

Plate 238 **1345** Corbridge 7A (nts): **1346** Corbridge 7B (nts): **1347**
Corbridge 6A: **1348** Corbridge 3: **1349** Corbridge 5A: **1350** Cor-
bridge 5B: **1351** Corbridge 5C: **1352** Corbridge 5D.

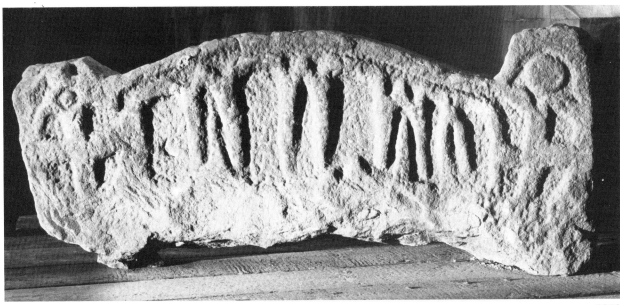

1353

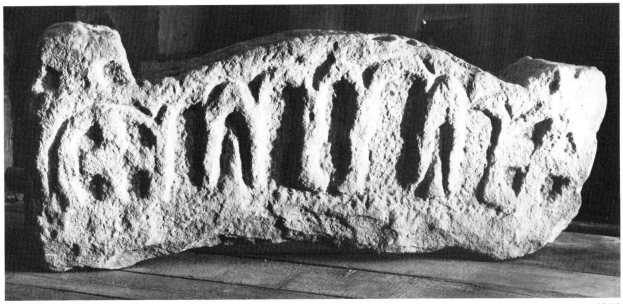

1354

Plate 239 **1353** Hexham 45A: **1354** Hexham 45C.

1355

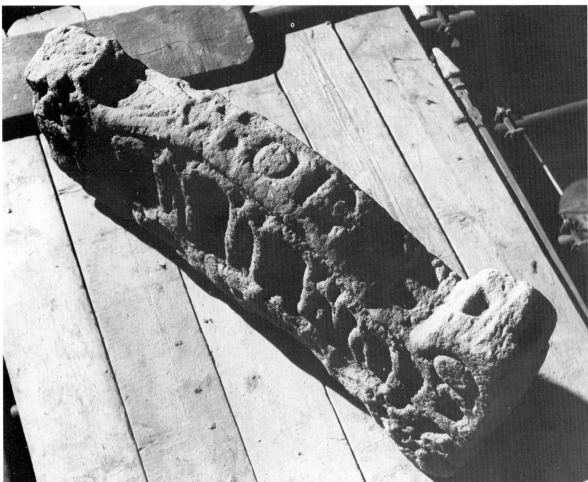

Plate 240 **1355** Hexham 44 (1:5): **1356** Hexham 45A.

1356

Plate 241 **1357** Kirkhaugh 1A (nts).

Plate 242　**1358** Kirkhaugh 1B (nts).

Plate 243 **1359** Kirkhaugh 1C (nts).

Plate 244 **1360** Kirkhaugh 1D (nts).

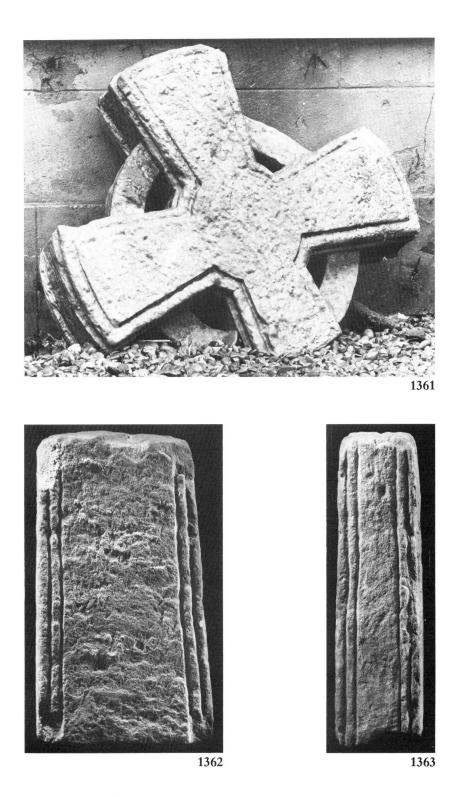

1361

1362

1363

Plate 245 **1361** Lindisfarne 45 (nts): **1362** Lindisfarne 44A: **1363**
Lindisfarne 44B.

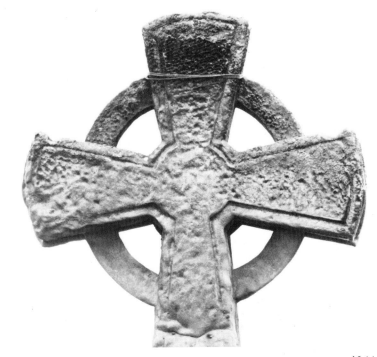

1364

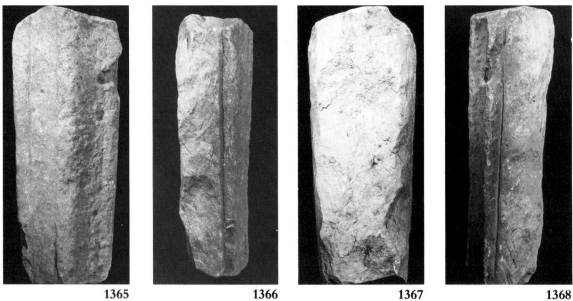

1365 **1366** **1367** **1368**

Plate 246 **1364** Lindisfarne 46: **1365** Lindisfarne 47A: **1366** Lindis-
farne 47B: **1367** Lindisfarne 47F: **1368** Lindisfarne 47D.

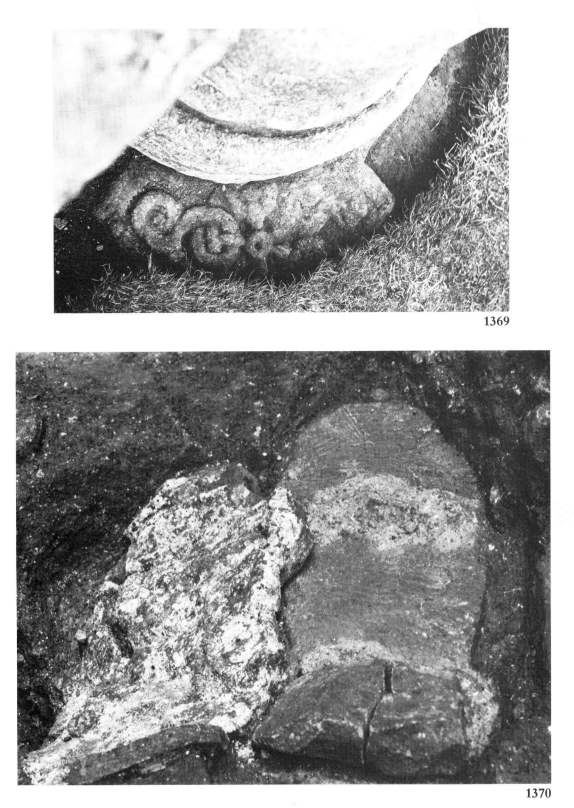

1369

1370

Plate 247 **1369** Lindisfarne 48: **1370** Newcastle upon Tyne 1A.

1371

1372

1373

1374

1375

Plate 248 **1371** Newcastle upon Tyne 1A: **1372** Norham 17A: **1373**
Norham 17B: **1374** Norham 18A: **1375** Norham 19A.

1376

1377

1378

Plate 249 **1376** Newcastle upon Tyne 1A: **1377** Newcastle upon
Tyne 2A: **1378** Newcastle upon Tyne 2A/B.

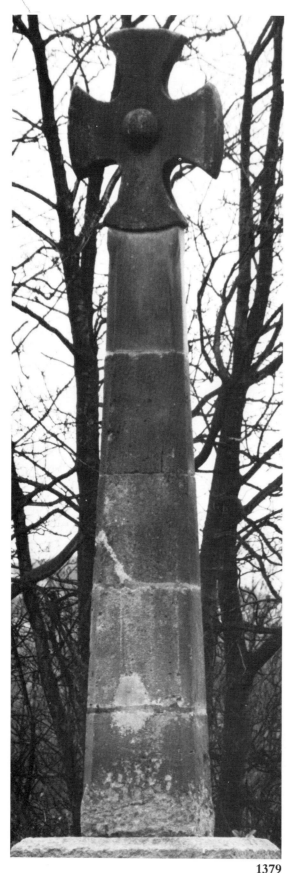

1379

1380

1381

Plate 250 **1379** Ovingham 3A (nts): **1380** Ovingham 3C: **1381** Ovingham 3B.

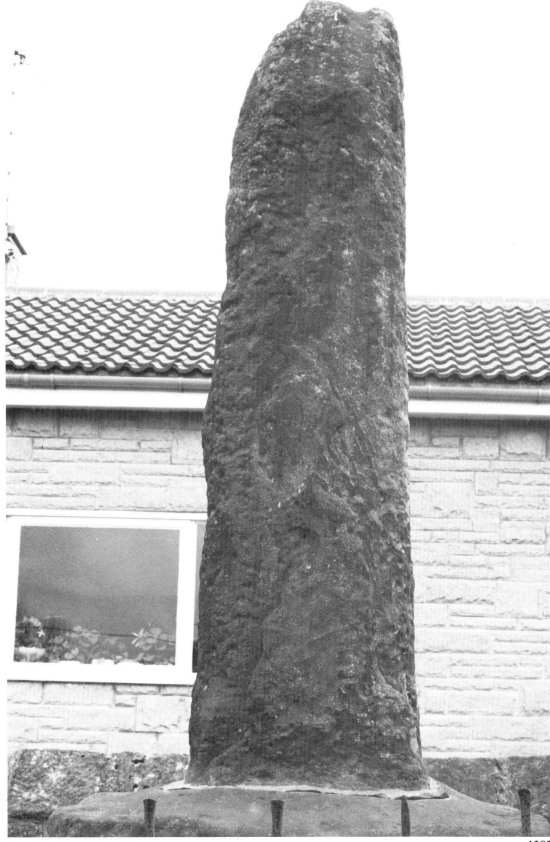

Plate 251 **1382** Ulgham 1A.

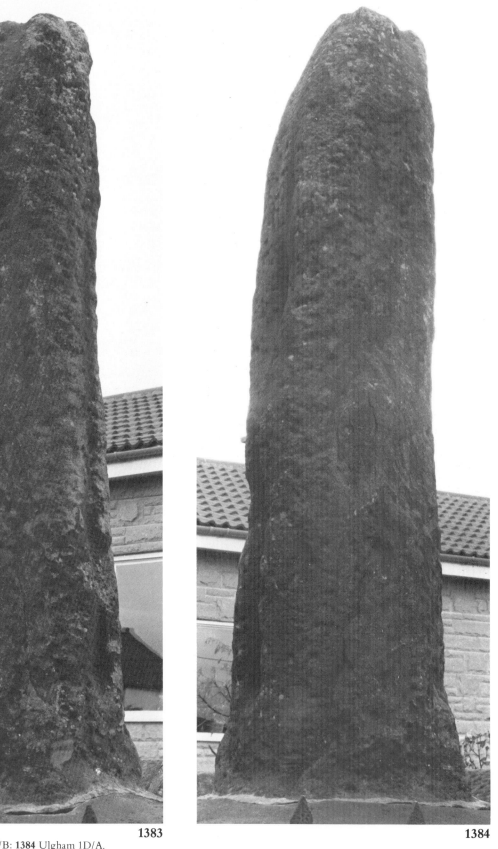

1383

1384

Plate 252 **1383** Ulgham 1A/B: **1384** Ulgham 1D/A.

Plate 253 **1385** Warden 3A: **1386** Warden 3B.

1387

1388

Plate 254 **1387** Warden 3C: **1388** Warden 3D.

1389

1390

1391

1392

1393

1394

1395

1396

1397

Plate 255　1389 Warden 4: 1390 Simonburn 6A: 1391 Warden 5A:
1392 Warden 5A/B: 1393 Warden 5C: 1394 Warkworth 3A: 1395
Warkworth 3B: 1396 Warkworth 3C: 1397 Warkworth 3D.

1398

Plate 256 **1398** Whittingham 1A.

1399

1400

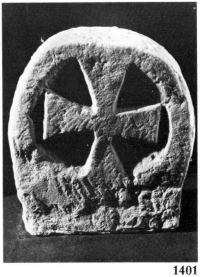

1401

Plate 257 **1399** Whittingham 1B/C: **1400** Woodhorn 2A: **1401** Woodhorn 3A.

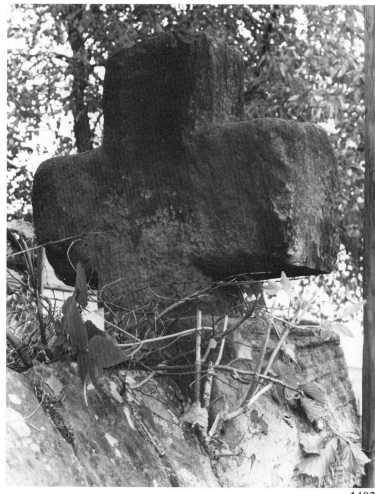

1402

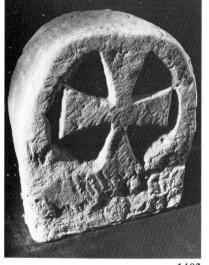

1403

1404

Plate 258　**1402** Whittingham 1C/D: **1403** Woodhorn 3D/A: **1404** Woodhorn 4A.

1405

1406

1407

1408

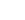

1409

1410

1411

1412

1413

Plate 259 **1405** Woodhorn 4C: **1406** Unknown Provenance 4A:
1407 Unknown Provenance 4B: **1408** Unknown Provenance 4C:
1409 Unknown Provenance 4D: **1410** Unknown Provenance 5A:
1411 Unknown Provenance 5B: **1412** Unknown Provenance 5C:
1413 Unknown Provenance 5D.

PLATES 260–267

COMPARATIVE MATERIAL

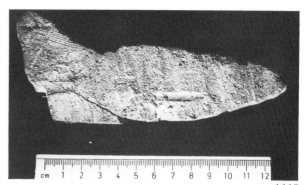

1414

1415

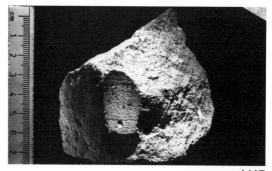

1416

1417

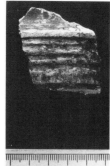

1418

1419

1420

Plate 260 **1414–20** Fragments from Monkwearmouth, showing
evidence of tools etc. used: **1414** marks of broad-bladed chisel
(1:2): **1415** marks of narrow-bladed chisel (1:2): **1416** multiple fine
marks, possibly of claw chisel (1:2): **1417** hollow for tip of lathe in
centre of end of baluster shaft (1:2): **1418** marking-out line for edge
of decorative strip (1:2): **1419** paint on plaster base, on baluster shaft
(1:2): **1420** marks of medium-bladed chisel (1:2).

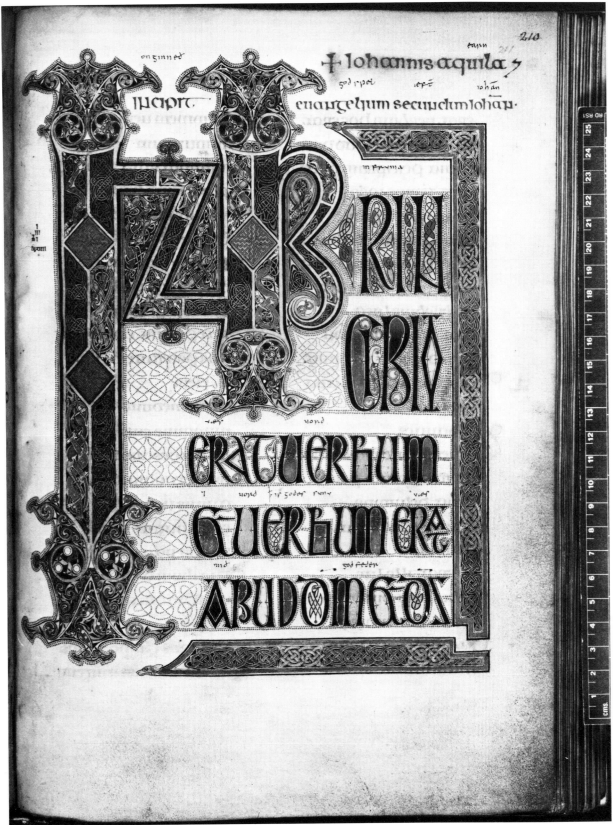

Plate 261 **1421** Lindisfarne Gospels, opening page of St. John's
Gospel, fol. 211r (nts).

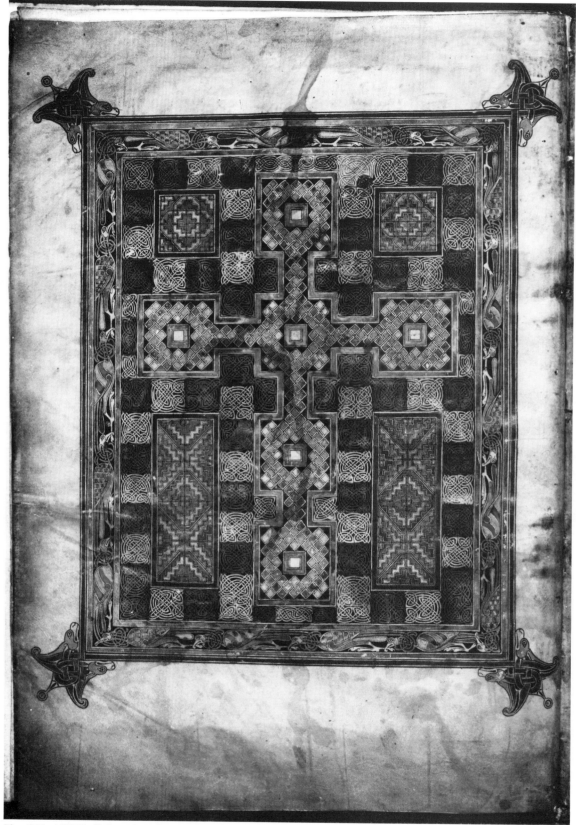

Plate 262 **1422** Lindisfarne Gospels, carpet page, fol. 2v (nts).

1423

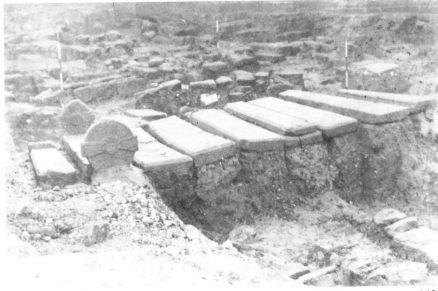

1424

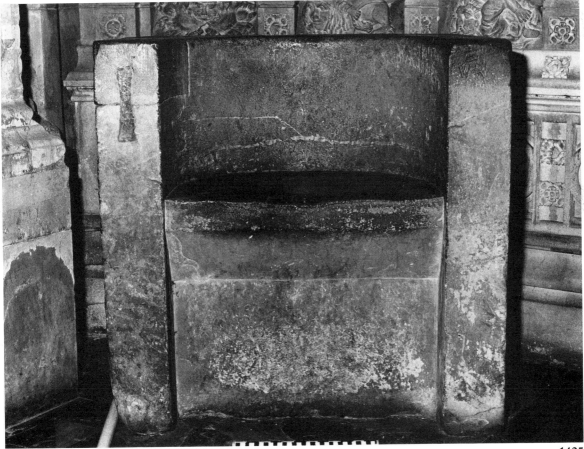

1425

Plate 263 **1423** Whitby (Yorkshire, N. Riding), baluster shaft in site museum: **1424** Whitby (Yorkshire, N. Riding), grave-markers and grave-covers of overlap period in course of excavation in monastic cemetery (nts): **1425** Beverley (Yorkshire, E. Riding), Anglo-Saxon 'frith stool' in minster.

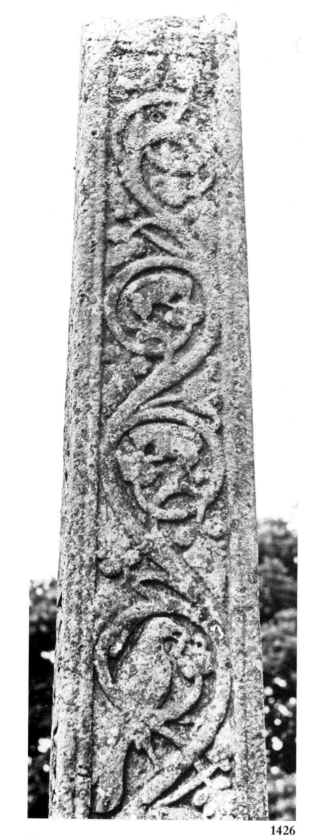

1426

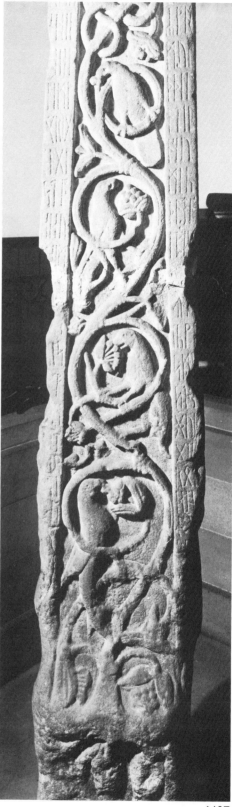

1427

Plate 264 **1426** Bewcastle (Cumberland), cross-shaft, top of E. face (nts): **1427** Ruthwell (Dumfriesshire), cross-shaft, bottom of W. face (nts).

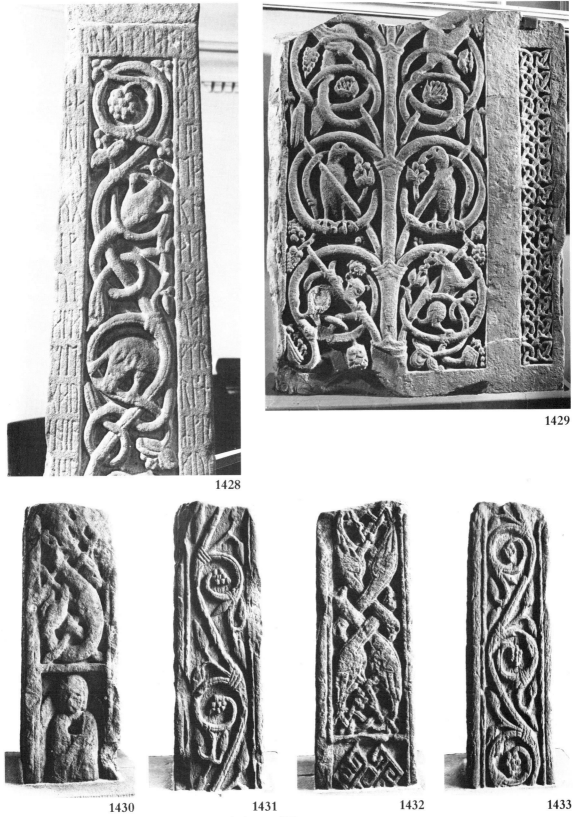

1428

1429

1430 1431 1432 1433

Plate 265 **1428** Ruthwell (Dumfriesshire), cross-shaft, top of W. face: **1429** Jedburgh (Roxburghshire), panel of shrine in site museum: **1430–1433** Aberlady (E. Lothian), cross-shaft, now in National Museum, Edinburgh (**1430** face A, **1431** face B, **1432** face C, **1433** face D).

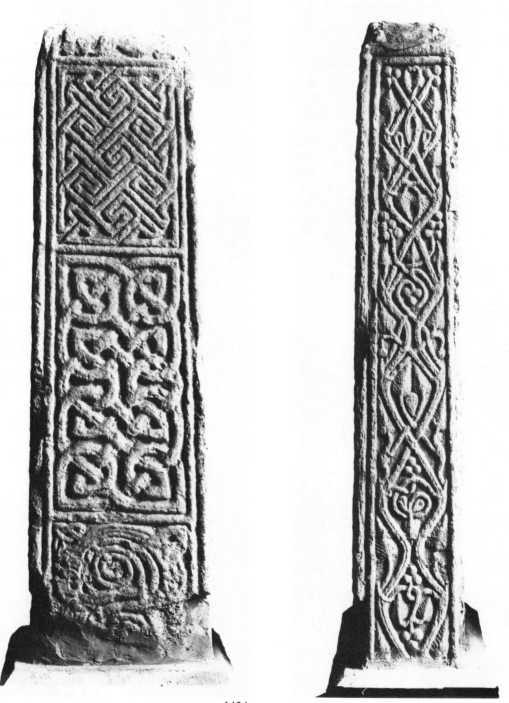

1434

1435

Plate 266 **1434–35** Abercorn (W. Lothian), cross-shaft (**1434** face
A, **1435** face B).

1437

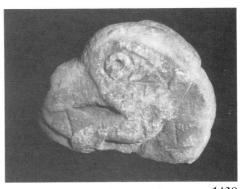

1438

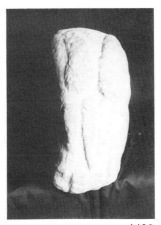

1439

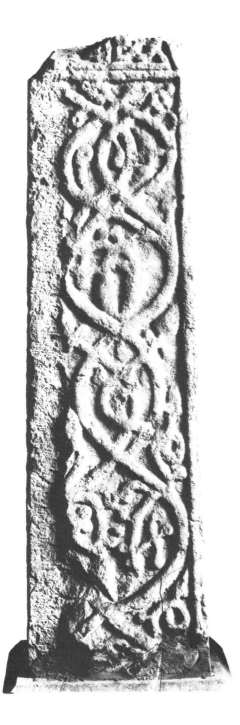

1436

Plate 267 **1436** Abercorn (W. Lothian), cross-shaft, face C: **1437**
Coldingham (Berwickshire), cross-shaft fragment, now in National
Museum, Edinburgh, face A: **1438–1439** Lastingham (Yorkshire,
N. Riding), animal head, probably part of arm of chair (**1438** face A
(1:5), **1439** face B (1:5)).